THE WATERCOLOURIST'S YEAR

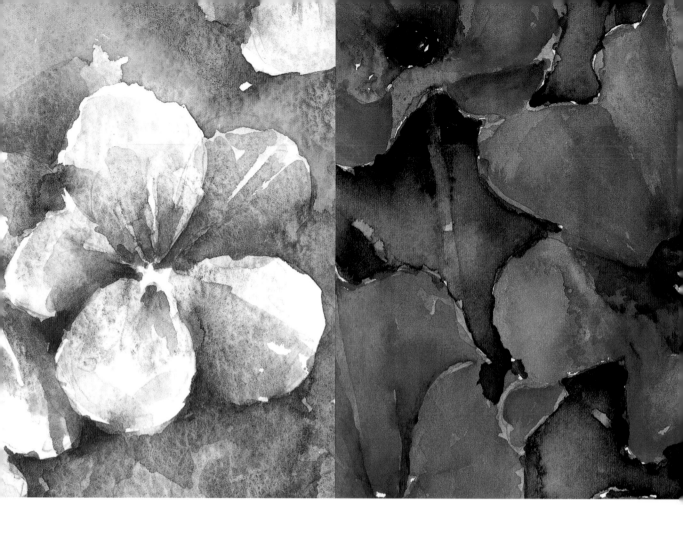

Richard Taylor

THE WATERCOLOURIST'S YEAR

How to use seasonal palettes effectively

First published in 2000 by
HarperCollins*Publishers*
77-85 Fulham Palace Road
Hammersmith, London W6 8JB

The HarperCollins website address is:
www.**fire**and**water**.com

Collins is a registered trademark of
HarperCollins Publishers Limited.

05 04 03 02 01 00
8 7 6 5 4 3 2 1

**A catalogue record for this book is
available from the British Library**

Editor: Geraldine Christy
Designer: Penny Dawes
Photography: George Taylor

A set of four videos to accompany
this book is available from
Teaching Art Ltd, P. O. Box 50,
Newark, Nottinghamshire
NG23 5GY

ISBN 0 00 413404 4

Colour reproduction by Colourscan,
Singapore
Printed and bound by
Rotolito Lombarda, Italy

Contents

spring

THE NEW
AWAKENING

summer

THE HEIGHT
OF SUMMER

autumn

THE TURNING
OF THE YEAR

winter

IN THE DEEP
MIDWINTER

INTRODUCTION

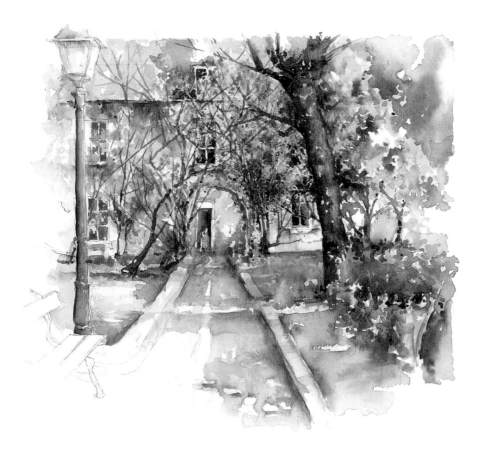

Spring Greens in an Artist's Garden
25 x 28.5 cm (10 x 11 in)

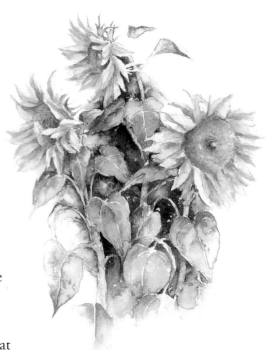

A Cluster of Summer Sunflowers
21 x 16 cm (8 x 6 in)

As an artist I have always responded to the seasons in different ways. During high summer I visit the seafront with my easel, and walk across the hills and mountain trails with my sketchbook and set of pan paints. During the winter months, however, I tend to find subjects that can either be recorded in the warm confines of my own home, or choose subjects that can be sketched quickly out of doors and transferred to an 'easel'-size painting back at home.

Spring and autumn are, in many ways, transitory seasons that lead us in and out of the extremes of summer and winter, and both have their own unique qualities – the rich colours of the forest in the fall, and the sharpness and clarity of a fresh spring sky, are both wondrous subjects to paint. But the studies we make and the natural artefacts that

we find at different times of the year are, to me, equally inspirational. A piccc of driftwood found on a hazy salt sprayed beach, clods of earth clinging to sodden boots that have walked the length of a ploughed field, a vase of tulips, and a sprig of berried holly, are all unique to their respective seasons and are, I believe, of equal worth to the artist.

For these reasons this book is divided into clearly defined seasonal sections, each starting with a palette that displays the dominant colours of the season. Many colours

Snapshot of the Corner of a Parisian Café
23 x 22 cm (9 x 8½ in)

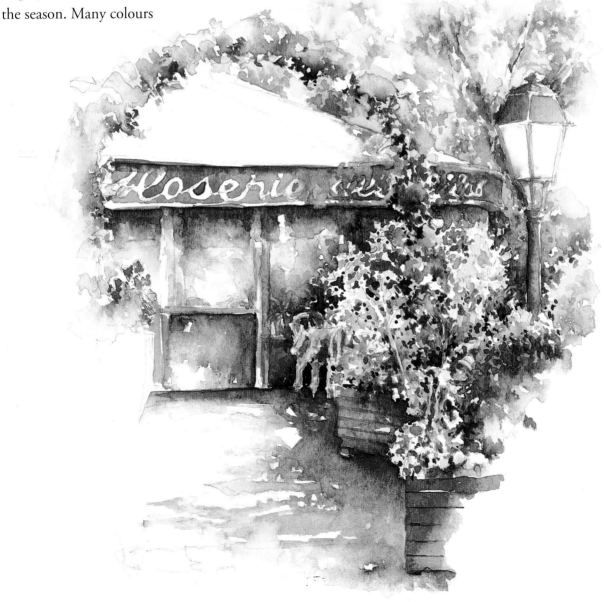

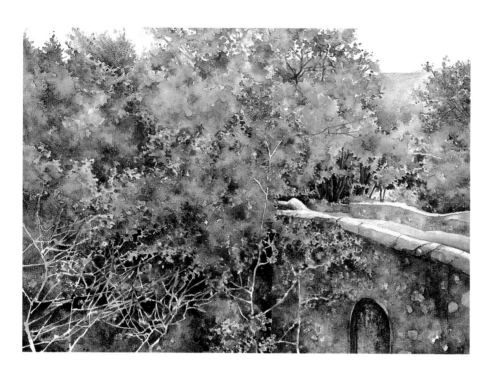

Forest in the Fall
31.5 x 44 cm (12½ x 17 in)

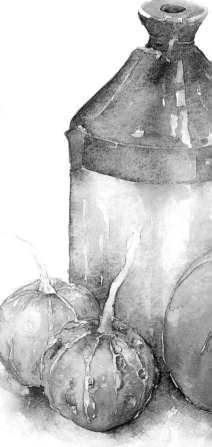

**Seasonal Still Life with
Stone Jar and Pumpkin**
29 x 26 cm (11½ x 10 in)

are used across the seasons – the natural earth colours being the most common – but these do not appear in every seasonal palette. The colours featured are the key colours that make that particular seasonal palette different from the others.

The sketchbook pages contain examples of the types of subject that I have found on my wanderings, and have either picked up or bought and taken home, or sketched where they lay. They are, I believe, the backbone of the artist's practice.

Throughout the book I have borne in mind the instructional as well as the inspirational aspects of painting throughout the year. Explanatory techniques pages deal with a different watercolour technique that is relevant (although not unique) to the particular season.

All artists like their comfort and for this reason I have included several 'table-top' studies. The aim of these is to help you to compose, sketch and paint a group of objects that you are likely to encounter in the relevant season in the comfort of your own home – on the dining, kitchen or studio table. They can often be painted at a more leisurely pace as the lighting will probably

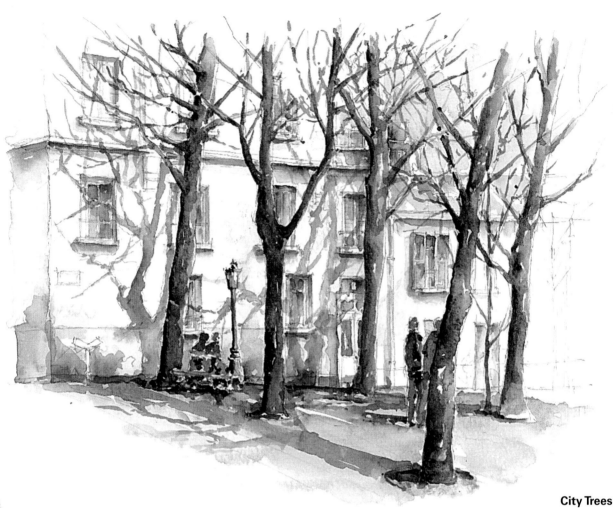

remain constant (unless they are positioned in front of a window) and you will not be at the mercy of the elements.

Finally, each section features a step-by-step demonstration that will take you through the exact process that I use when painting out of doors, starting with the first wash and working through to the finished picture, chosen for its seasonal qualities.

All seasons have their qualities – try to make the most of them all.

Richard Taylor

MATERIALS AND EQUIPMENT

Kitchen roll
Kitchen paper is ideal for blotting excessive water from paper.

As the seasons change, so does most artists' choice of equipment. During the colder periods that seem to run from late autumn through to mid-spring certainly the weather encourages me to spend most of my time in the warmth and comfort of my studio. As soon as the warm breezes start to waft through my window carrying the sweet smells of fresh blossom, however, I start to pack the bag that I take out on painting expeditions.

I make a clear distinction between my studio equipment (usually larger as portability need not be an issue) and the smaller, more compact equipment that I use outside.

Brushes
I use as small a selection of brushes as I can. Synthetic brushes are, nowadays, an accessible alternative to brushes made of natural hair such as sable and squirrel.

studio equipment

When working in the studio I usually paint onto heavy-duty 535 gsm (250 lb) watercolour (Not) paper, using sheets of 762 x 539 mm cut in half, occasionally carrying out some sketches on an A2 watercolour sketchpad. As I prefer to use tube paints in the studio, I use a fairly large plastic palette (Spencer Ford) to squeeze them into. This has a lid, allowing me to close it up and put it away after a painting session. I choose tube paints as they can give instant 'body' to a painting, yet can be diluted to create the subtlest of washes.

I use only a few brushes and these fall into three simple categories – large, medium and small. Given the expense of pure sable brushes, I tend to use synthetic brushes – it is nowhere near so upsetting to lose these! My long-handled large wash brush feels good to hold and to move across a sheet of paper.

Watercolour paints
A box of pan paints is invaluable for outdoor sketching as they take up so little space.

Tube paints
Tube paints can afford the painter a deeper, stronger colour, but can also be highly diluted.

Large chisel-head brush

Small chisel-head brush

Small watercolour brush

Medium watercolour brush

Large watercolour brush

Selected colours from
Daler-Rowney's range
of Artists' Quality
watercolours

Sheet cartridge paper

Tinted watercolour paper

Smooth watercolour paper

Ringbound pad watercolour paper

Rough-textured watercolour paper

Ringbound pad cartridge paper

Masking fluid

This can be a valuable medium *(right)*, used for masking areas of paper that need to be kept white, and can be applied with a variety of implements.

Papers

Watercolour paper is available in a wide variety of types, qualities and sizes, either loose or in sketchpad form. My personal choice is for a 535 gsm (250 lb) Not paper.

Pencils

I use 2B, 4B and 6B pencils, as well as a range of soft-leaded 'sketching' pencils for shading.

Sharpeners

A pencil sharpener is quick, but a piece of sandpaper will allow you to maintain a point without wasting the pencil.

Putty eraser

A useful tool for correcting mistakes or removing pencil marks without damaging the surface of the paper.

For the bulk of the actual painting I use a springy, medium size brush that can hold a lot of water and maintain a reasonable point. Finer details require a more delicate brush with a good point.

I occasionally use masking fluid (see Masking, pages 86–87) and usually apply this with an old ink pen, twig, or sometimes even a toothbrush.

For drawing, I like to use an A2 sketchpad with heavy-duty cartridge paper and a selection of 2B, 4B and 6B pencils along with a large putty eraser.

outdoor kit

When the weather allows me to venture outside I need a simple set of highly portable equipment – the main item being a box of pan paints. These blocks of paint have to be 'worked up' with water, but can then be mixed in the lid (some of the more elaborate boxes have water carriers attached). Many of these boxes have room for a small retractable brush, which I make much use of. I also carry a wash brush and a medium size, general-purpose brush.

For painting I carry an A3 hardback sketchbook with 425 gsm (200 lb) watercolour paper, and for drawing I use another A3 hardback sketchbook, only this time with cartridge paper. I use the same pencils as I do indoors.

I always ensure that I have a small plastic bottle of mineral water with me as I can never be sure where I will find a source of water with which to paint.

The seasons all have their different appeal for artists – the weather, the quality of the light, the 'fruits' of the season, the ground colours, the temperature and the number of daylight hours available to paint by.

spring

Spring is usually the time when the natural world wakens from its dormant state and colour starts to return to the landscape. It is also frequently a season of strong winds, scudding clouds and fresh skies that can offer days of warm, redolent breezes, or downpours and gales.

One of the predominant features of the spring months is the strength and colours of the shadows cast by the fresh, sharp, yet often cold, light. While the light may be bright, these days rarely hold the warmth of the summer sun and can, therefore, be deceptive. Cool blues and greys dominate the shadows. The fresh greens of a springtime landscape are awash with blues, the buildings still hold onto the cold greys of winter, and the newly formed buds and flowers on the trees still cast blue-tinged shadows onto the surrounding ground.

The First Growth of Spring
25 x 34 cm (10 x 13 in)

The combination of stark, bare branches and the first growth of spring leaves are a pleasure for artists to record.

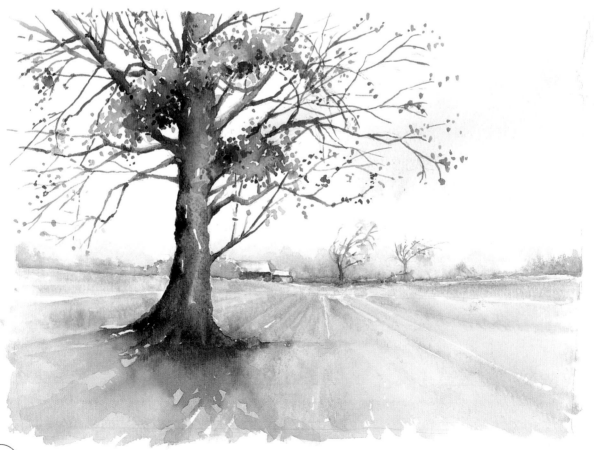

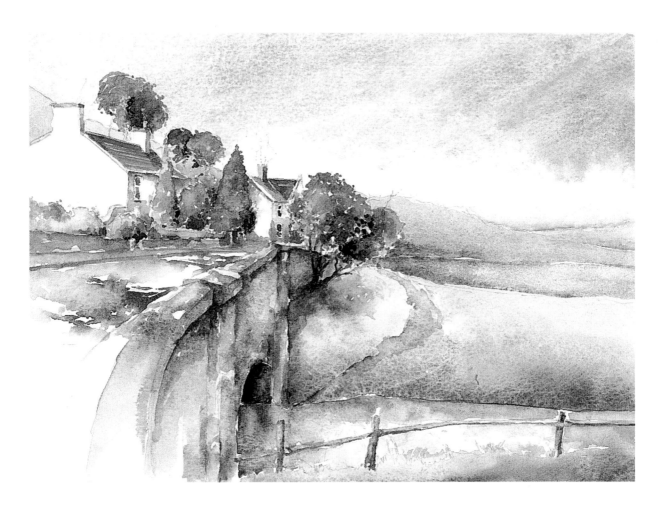

summer

The summer landscape is usually awash with light and shade – either the strong solid shadows that accompany the harsh midday sun, or the softer dappled shadows that shift and flicker with the gentle summer breezes. Whichever you are confronted with, the dominant colours of summer will be in the warm range – oranges, violets and reds, and the warm blues. Violets feature in most shadows in the summer landscape.

Colours at midday can be intense. Their brilliance and glare can make painting in the heat of the summer sun particularly difficult. I usually prefer to paint early in the morning when the colours are softer, or in the late afternoon when the blues and violets are deeper and stronger in the lengthening shadows.

The ground, as always, should contain a little of all the dominant features and colours in the rest of the landscape.

Early Morning Summer Shadows
24 x 34 cm (9½ x 13 in)

The strong, warm shadows with their violet hues are a major feature of this early morning summer scene.

autumn

The autumn landscape is probably the most colourful because the colours actually appear in the trees and the woodlands and are not just the result of the effects of light. Across the landscape fiery colours appear and bare branches begin to emerge.

Forests are a particularly popular subject with artists at this season, but there is more on offer at the turning of the year than woodlands and leaves. The produce of the land, the harvest and the fruits of the orchards all make highly desirable subjects for sketches, studies and paintings.

As the year draws to a close with the fields harvested, the landscape returns to its natural state once more and the rains often come to soak the ground. This is the time when the sky colours are captured by the ploughed earth and reflect all the colours that are contained within the immediate environment.

After the Autumn Rain
28 x 39 cm (11 x 15 in)

Autumn is a season of vibrant colours, damp earth and atmospheric skies. Colours abound across the open fields.

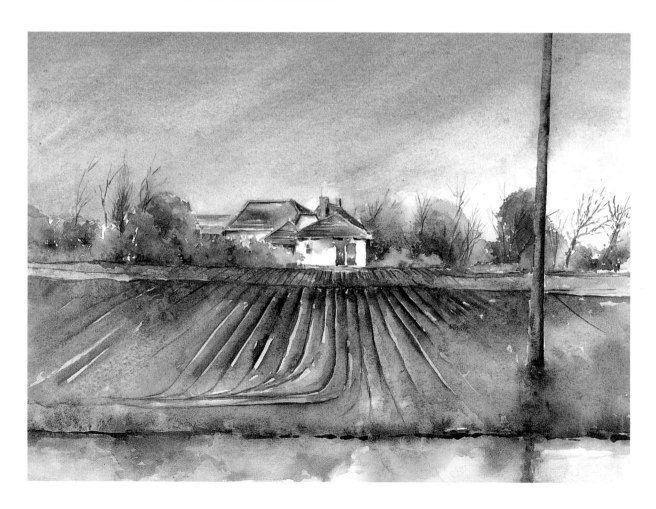

winter

Winter is a season for the brave outdoor painter. Biting winds and driving snow are frequent obstacles, but worth putting up with to capture some of the most atmospheric of scenes.

This can be a season of sharp frosts and low, hard light. The dominant colour of many winter landscapes is grey, although this is not to suggest that the winter landscape does not 'hold' colour. The colours are simply colder and frequently more muted. Cool greens and greys dominate the landscape and make a foil to the festive decorations that begin to appear in towns and cities.

Even the natural warmth of the siennas and umbers that are to be found in old stone appear to be wrapped in a transparent grey film as winter takes hold of the landscape.

The First Big Winter Snowfall
37 x 54 cm (14½ x 21 in)

The snows that accompany the winter season can impose a whole new order on the landscape through shape and colour.

LOOKING AT COLOUR

The colours of the natural world are rarely to be found in paint tubes – we have to mix colours and create those that suggest the colours we see. Colour is, therefore, an area in which artists best learn about the qualities of paints through their own experimentation. Throughout this book I have highlighted the 'key' colours that I use for each season. Spring subjects will make good use of Lemon Yellow, Rose Madder, Cobalt Blue and Sap Green. My summer colours are Cadmium Red, Cadmium Yellow, Alizarin Crimson and French Ultramarine. In autumn I choose Raw Sienna, Burnt Sienna, Burnt Umber and Cadmium Orange, while the winter months require the use of Terre Verte, Payne's Grey, Raw Umber and Yellow Ochre.

colour temperature

Many colours are perceived by artists to have a colour 'temperature' – that is, they can give the impression of warmth or coldness to the viewer. Traditionally, blues and violets have been considered to be the colder colours, while reds and oranges have always been used to impart a feeling of warmth. These are not, however, hard-and-fast rules – or fact – but are simply the way in which we may perceive these colours.

This is one of the true joys of painting – experimenting with colours and watching a scene change its 'feel' according to the paint that you apply, perhaps by 'warming' a still life of autumn fruits, or 'cooling' a cold November street scene.

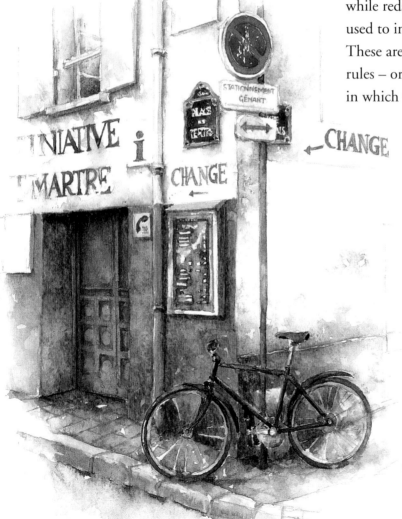

Parisian Street Corner
26 x 21 cm (10¼ x 8 in)

The cool street corner relies heavily upon blues and greys to produce the effect.

18

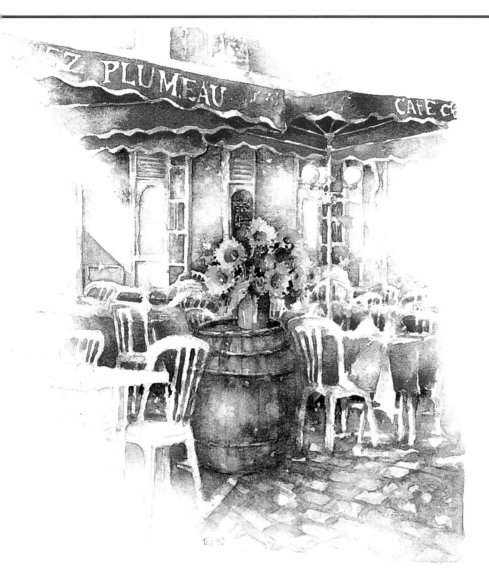

Mediterranean Café
26 x 23 cm (10¼ x 9 in)

Awash with colour, this
Mediterranean café
depends on warm violets
for its areas of shadow.

Shadows can be mixed
to impart either a 'cold'
or 'warm' feeling.

Several colours can be used outside
their considered colour temperature.
Cobalt Blue, for example, when mixed
with a touch of Payne's Grey, will give the
impression of cold, winter light if used as
a shadow colour. However, another blue,
French Ultramarine, when mixed with a
touch of Alizarin Crimson, will form the
perfect colour for sun-baked summer
shadows. These, of course, can be
intensified by using more paint, or diluted
by using more water – you choose
according to the scene you are painting.

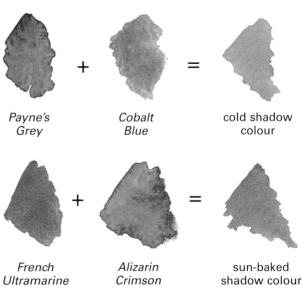

Payne's
Grey
+
Cobalt
Blue
=
cold shadow
colour

French
Ultramarine
+
Alizarin
Crimson
=
sun-baked
shadow colour

colour mixing

Some colours are common to all seasons, but are used with different colours, in different combinations, to create widely varying effects. Sap Green is a particular example. If mixed with Lemon Yellow and Cobalt Blue it will create a cool, spring-like green. If mixed with Terre Verte, which is a cold grey-green, this will turn even cooler still. If, however, Sap Green has Cadmium Yellow and French Ultramarine added, it may provide a warm base colour for summer foliage. A touch of Burnt Umber will provide a particularly dark version for shadows on trees and bushes.

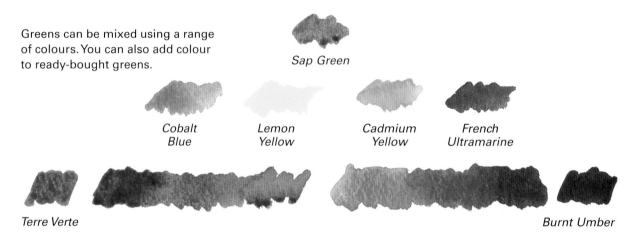

Greens can be mixed using a range of colours. You can also add colour to ready-bought greens.

Sap Green

Cobalt Blue *Lemon Yellow* *Cadmium Yellow* *French Ultramarine*

Terre Verte *Burnt Umber*

colour combinations

Some colours are natural allies and work together particularly well. The natural earth colours are good examples of this – for example, Raw Sienna and Burnt Sienna combine well to create the warmth of aged stone. Alizarin Crimson (with a touch of French Ultramarine) combines well with the siennas to produce a series of colours that are perfect for rendering the varied tones of brickwork. Many other colour combinations are equally effective, and great fun to discover.

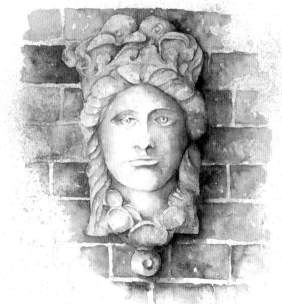

Terracotta Wall Sculpture
36 x 31 cm (14 x 12¼ in)

The warmth of this terracotta statue is captured by combining natural earth colours with Alizarin Crimson.

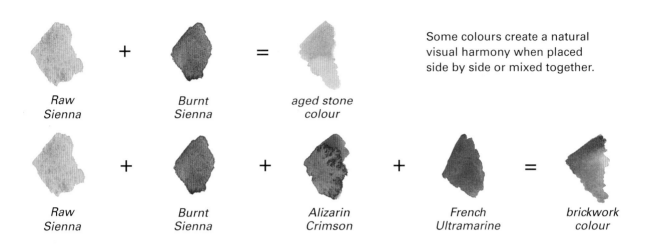

Raw Sienna + Burnt Sienna = aged stone colour

Some colours create a natural visual harmony when placed side by side or mixed together.

Raw Sienna + Burnt Sienna + Alizarin Crimson + French Ultramarine = brickwork colour

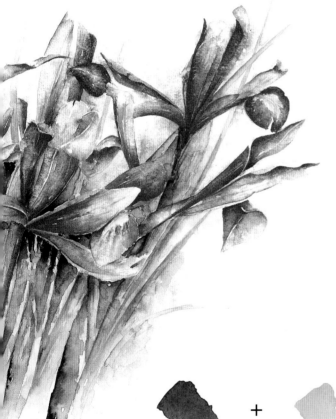

Wild Irises
35 x 27 cm (13¾ x 10½ in)

The greens and blues here were recorded using the natural cool tones of Payne's Grey mixed with warm Cadmium Yellow.

An unusual combination of Payne's Grey and Cadmium Yellow provides a good, albeit cool, green (because of the blue content of the Payne's Grey paint), and will work extremely well with a little Hooker's Green to create the foliage, leaves and stems of spring plants.

To increase the depth of tones, creating a darker green, add some more Payne's Grey. To create a bright, fresher colour, add less Payne's Grey rather than adding more yellow.

Payne's Grey + Cadmium Yellow = cool green

Fresh spring greens need delicate mixing. Use a light touch in the palette.

Payne's Grey + Cadmium Yellow + Hooker's Green = spring green

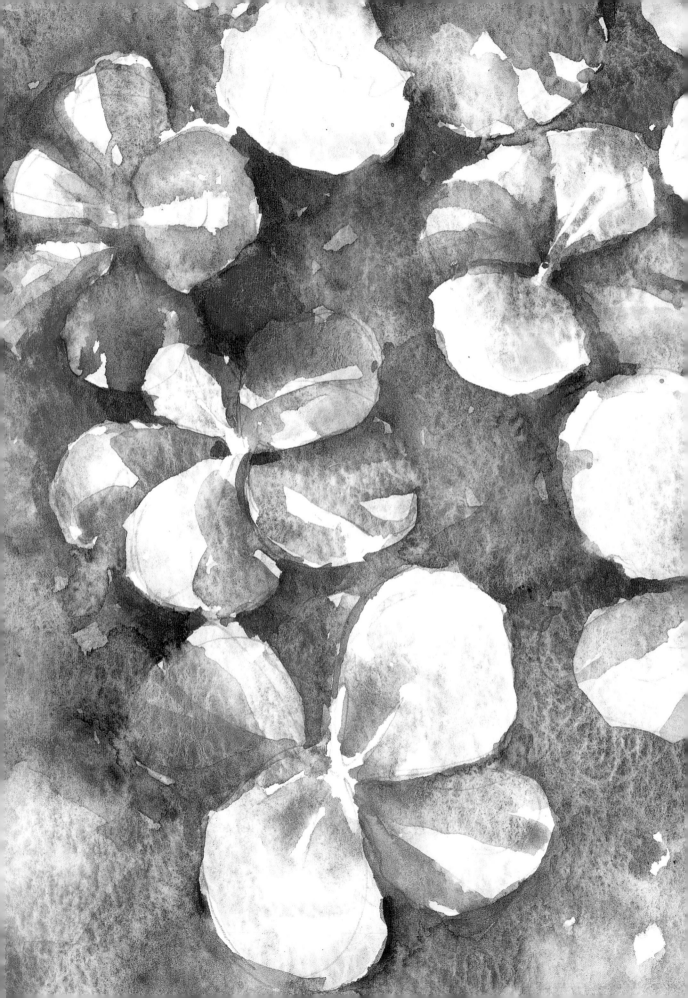

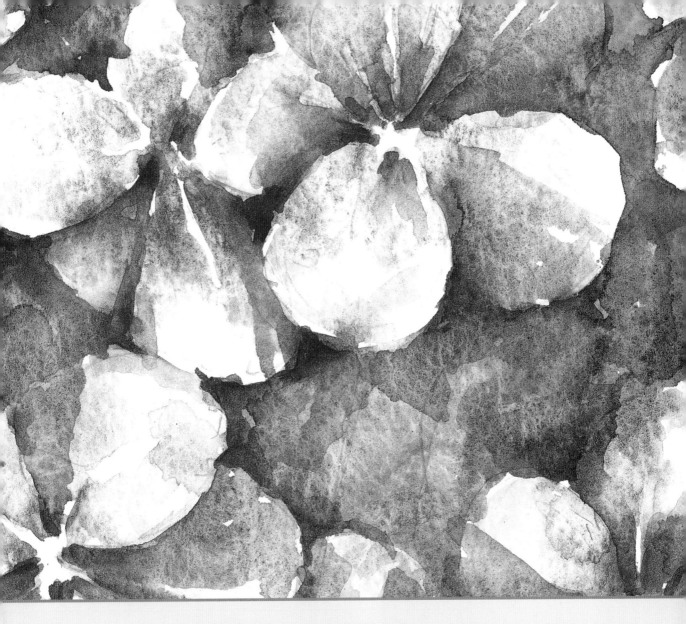

THE NEW AWAKENING

The amazing variety of soft, cool colours and tones that are to be found in bushes, trees and hedgerows at the birth of the year as nature awakes from its winter slumber are ideal for recording in watercolour. The yellows, pinks and blues of the new growth blend subtly, almost imperceptibly, to create some near-abstract images.

spring

Spring is a time of awakening for nature and artists alike. Bulbs penetrate the surface of the soil, buds burst into life and the natural world begins to fill with colour. This is my cue to start packing my art bag and to move outside to explore, filling my sketchbook pages with the images of fresh, new colour and sharp, intense light.

The colours in this season require a palette that is dominated by cool and fresh-looking paints. Cobalt Blue and Prussian Blue are both colours that impart a cool feel, and many greens also tend to have a strong blue bias. The yellowish Sap Green is a fairly warm green, and can be toned down by the addition of blue. The colours of the flowers and blossoms of the season are dominated by yellows and pinks – Lemon Yellow and Rose Madder are ideal.

Of course, the natural earth colours will be evident in the fields at this time as they are prepared for the growth of their fruits and produce, but these will all be tempered by the addition of the above-mentioned colours. The coolness of the sky and the blues used to depict it will always reflect upon the ground.

palette
cherry blossom

Rose Madder

Alizarin Crimson

Payne's Grey

Rose Madder forms the base for the tree blossom. Cool spring shadows cast on the house are a mixture of Payne's Grey, with a touch of the blossom colour added to enhance it. A touch of the colours of any predominant feature works well when added to the shadow mixture – after all, light is also reflected from the object, so it carries a little of that colour with it.

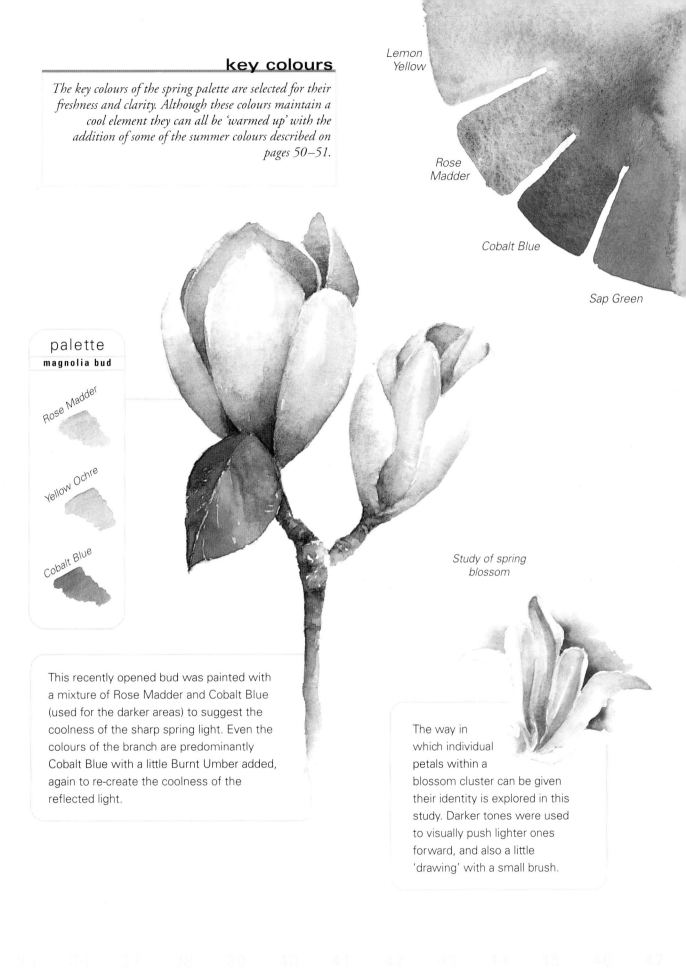

key colours

The key colours of the spring palette are selected for their freshness and clarity. Although these colours maintain a cool element they can all be 'warmed up' with the addition of some of the summer colours described on pages 50–51.

Lemon Yellow

Rose Madder

Cobalt Blue

Sap Green

palette
magnolia bud

Rose Madder

Yellow Ochre

Cobalt Blue

Study of spring blossom

This recently opened bud was painted with a mixture of Rose Madder and Cobalt Blue (used for the darker areas) to suggest the coolness of the sharp spring light. Even the colours of the branch are predominantly Cobalt Blue with a little Burnt Umber added, again to re-create the coolness of the reflected light.

The way in which individual petals within a blossom cluster can be given their identity is explored in this study. Darker tones were used to visually push lighter ones forward, and also a little 'drawing' with a small brush.

O ne of the most exciting aspects of the spring season is
watching nature at work as buds and bulbs start to
burst through the earth's surface, and the lemon yellows and
cool blues and violets carpet the ground as wild flowers come
to life. Walking through woodlands, parks and gardens, I
constantly look for signs of these colours. Vibrant little
flashes amongst the cold, dark earth are always a sure
sign of warmer days to come. I am also very aware
of the fact that these flowers are not mine to take
away – I must either sketch them on site or
buy my own on the way home!

*Sprouting bulbs make an ideal
subject for a pencil study. I used a
2B pencil line to emphasize the
rounded shapes and a 4B to
shade and create the form.*

*'Drawing' with a small brush
captured the linear qualities of the
compact skin. Natural earth colours
re-create the colours of the bulb,
washed onto dry paper and
'pulled' in the direction of
the bulb's shape.*

*Rose Madder is a
fugitive colour that
dries to a light tone, so
needs a touch of
Cobalt Blue and
Alizarin Crimson.*

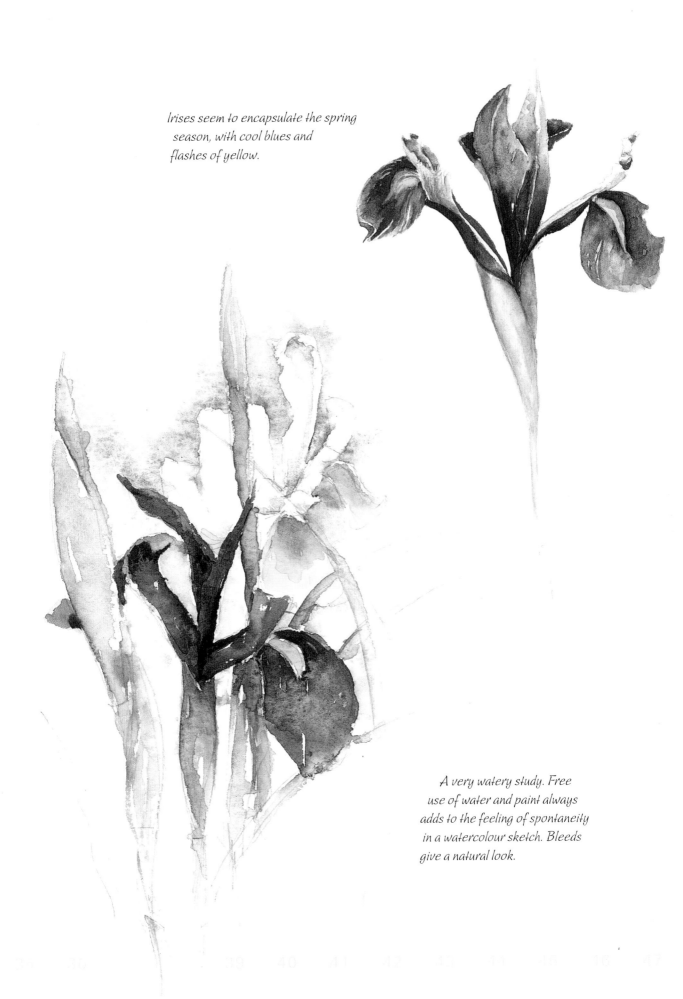

Irises seem to encapsulate the spring
season, with cool blues and
flashes of yellow.

A very watery study. Free
use of water and paint always
adds to the feeling of spontaneity
in a watercolour sketch. Bleeds
give a natural look.

Colour mixing becomes important when sketching spring plants
and flowers as a wealth of soft and varied tones are to be found.
These colours are not available in paint tubes, so you
will need to mix them yourself. If you do not wish
to create a finished painting, a few quick
decisive colour washes are usually
all that is required. You might like to
make a few notes on the colour mixes
that you use for future reference.

*A Lemon Yellow
underwash 'cements' the
colour of the tulips. Shadows
cast by the petals are created by
picking up some of the green
colour used for the leaves and stems.*

*Softer, more watery yellows
and greens can be very
effective for producing
cooler tones of colours.*

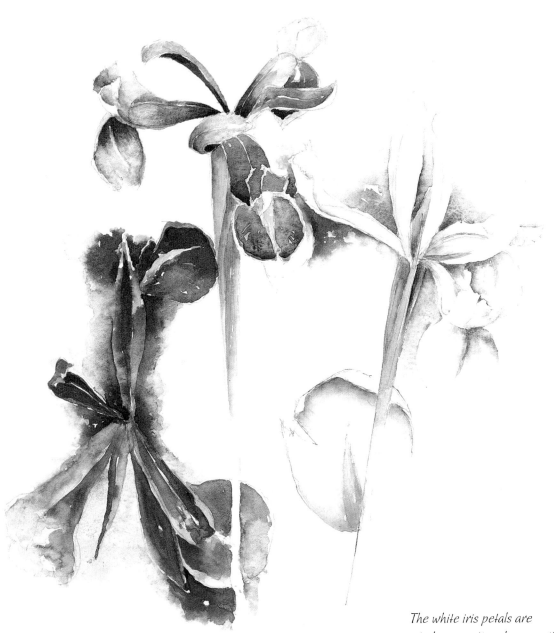

*The white iris petals are
created as negative shapes, with
the paper maintained as the sharpest
white. Flashes of colour on the white petals
are painted by underwashing Lemon Yellow
and, while still damp, touching in a little
orange towards the outer edges.*

Watercolour can be a subtle medium, ideal for the application and building up of washes – especially when used on soft round shapes like eggs. For this type of subject, as with most watercolour painting, it is important to establish an underwash. As watercolours are translucent, every subsequent layer of colour applied will be affected by the colour and strength of the underwash. These layers need to be painted when the previous underwash has dried. It is as well to attempt to build up only three or four layers of paint, as any more applications can depress colours and create a muddy appearance.

1 Create a symmetrical, oval shape, copying the proportion of the egg so that it is wider at the bottom, and narrower at the top. Use a smooth, even line.

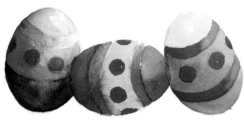

Decorative subjects with more than one colour are ideal for building up layers of watercolour. The principle of laying one colour on top of the other still applies – you simply need more colours.

2 Paint an even coating of clear water onto the shape. Leave while the water soaks into the watercolour paper and evaporates. Once the surface water can no longer be seen and you can detect an even sheen on the paper, apply the first layer of paint. Load a medium size brush with Payne's Grey and paint around the edge of the egg. The paint will bleed inwards on the damp paper and dry without a visible line.

3 Having established the undertone and a sense of form, you can start to add colour. Prepare a watery mixture of Cobalt Blue and wash this on, pulling the paint around the outer shape and leaving a highlight towards the centre top to suggest reflected light on the egg.

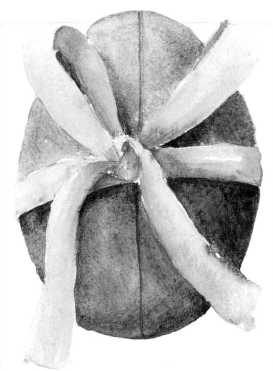

Basic egg shapes are often enhanced by the addition of ribbons. The flowing lines of the cloth emphasize the simplicity of the egg's curves.

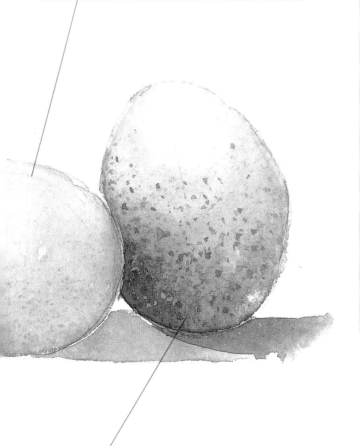

4 Add some of the speckled decoration that makes eggs so visually appealing. Do this by adding a little French Ultramarine to the basic colour mixture of Payne's Grey and, using a small brush, touch lots of tiny dots onto the egg. Make the greatest concentration of dots towards the base where the tone is naturally darker.

SUMMING UP

You can build up layers of watercolour paints because of their translucent qualities. Be careful to restrict yourself to a few washes only, however, as too many will reduce the impact by muddying the colours.

The feathery nature of chickens and hens make them ideal subjects for practising dry brush technique. With 'dry brush' you use only a little paint each time a new colour is introduced, with barely any water at all – hence the term. Your paintbrush becomes more of a drawing tool. The initial stage in this process, however, is to establish an underwash of the basic, underlying colour. For this particular subject it is a mixture of Yellow Ochre with a touch of Cobalt Blue. The subtle tones of brown and grey are then applied one after the other, building up layers of colour by almost drawing onto the chicken.

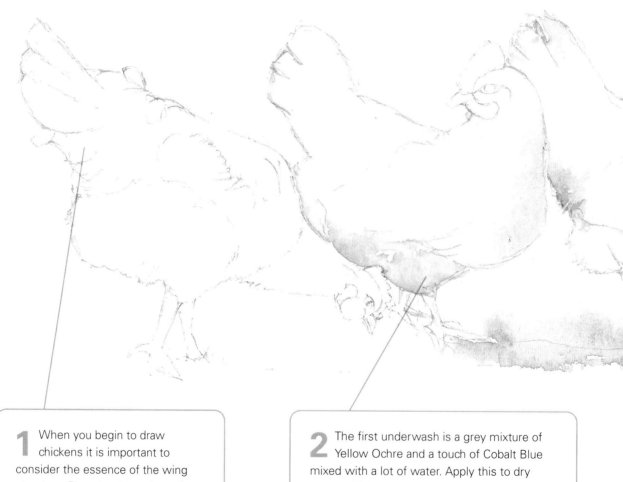

1 When you begin to draw chickens it is important to consider the essence of the wing structure. Do not get caught up in trying to record the shapes of all the individual feathers – suggestion of shape and texture is the key here. Try to see the groups of feathers as a whole, ragged-edged wing.

2 The first underwash is a grey mixture of Yellow Ochre and a touch of Cobalt Blue mixed with a lot of water. Apply this to dry paper with loose, broken brush strokes, allowing sections of white paper to show through. These areas of white will eventually represent some of the pure white feathers that can be picked out. You will need to use some water at this stage, but do not flood the paper.

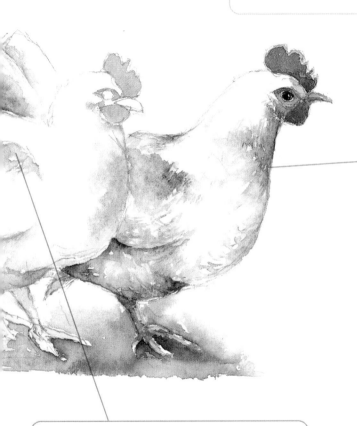

Chickens will sometimes stand still long enough to enable a quick sketch. The dry brush technique will allow you to combine painting skills with a few drawing techniques to complete the smaller details.

4 Add the final details by changing and strengthening the dryish colour mixture. For the brush strokes that suggest the feathers and create the shadows, use a mixture of Yellow Ochre, Burnt Umber and Payne's Grey. Paint these colours onto a dry surface with a few short, sharp brush strokes, following the directions of the feathers on the chicken. Treat your paintbrush almost like a pencil to achieve the dry brush effect.

SUMMING UP

Dry brush technique is best used for subjects where suggested detail is required. Using your brush rather like a pencil will allow you to position 'dry' paint on dry paper, rather than allowing a free flow that occurs with wet paint on wet paper.

3 Once the underwash is dry, prepare the colour mixture of Yellow Ochre and a touch of Payne's Grey with considerably less water. Using a small brush, apply this to the top of the wing where the browner feathers are seen, and around the breast to emphasize the form, suggesting the rounded shape of the chicken.

Mixing colours is, potentially, one of the most difficult aspects of watercolour painting, but it can also be one of the most rewarding. In the wash and dry brush techniques described on pages 30–31 and 32–33 the colour was applied almost in its pure state. This time, the colours need to be mixed in the palette before applying them. Unless otherwise stated, these colours are usually mixed in near even quantities. It is important to start off with the lightest colour and add the darkest colour last. In this exercise the cool colours of the foliage are mixed by using a selection of blues and greens, and brick colours are mixed by using natural earth colours.

1 First try to make some visual sense of this wild growth. Begin by drawing the main leaves and flower heads that can be clearly identified. As it is neither possible, nor visually desirable, to draw every single leaf and petal, it is important to select the most obvious and striking. With subjects like this, simply choose those details that catch your eye.

A single wild flower against an old brick wall offers a range of possibilities for watercolour studies.

2 Establish the cool green undertones of the wild undergrowth. Create a mixture of Sap Green with a touch of Cobalt Blue in the palette and wash it freely across the drawing. Put a wash of Raw Sienna and Cobalt Blue across the brickwork to underpin the colour of the bricks.

3 Once the underwash is dry, the line drawing becomes important once again. Mix a stronger version of the brick underwash colour in the palette and paint in between the leaf shapes, visually pushing them forwards. Then paint the bricks, this time using a mixture of Burnt Sienna and Burnt Umber, picking out the shapes as you have drawn them.

4 Before the paint dries touch a mixture of mainly Cobalt Blue with a little Payne's Grey onto the brickwork, allowing it to spread and bleed. This will create the feeling of age and texture. Add the same mixture to Sap Green, but this time add much more blue. Apply it to the very deepest, darkest areas of green growth, creating a strong contrast to the lighter leaves previously created.

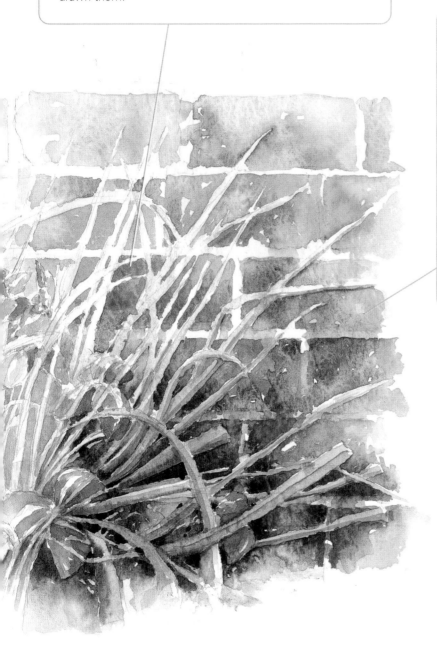

SUMMING UP

As you will rarely find the colours that you need in paint pans or tubes it is essential to learn to mix the colours that you want.

Painting white objects set against other white items raises an assortment of compositional questions. The first point to think about is which objects to place in front of, next to, or alongside others. If two or three objects are all placed in front of a central one there will be very little pictorial space to look through, and you will have to build up a complex web of subtle shadows around the central object in your painting, especially as no real colour is involved. This can create quite an impact with all objects visually connected by light and shade. If, however, the subjects are separated and laid out almost in a line, many visually appealing negative shapes will occur in between the objects, creating a less dynamic, but possibly more passive and attractive, composition. The next question, then, is should the composition be upright (known as portrait format) or lengthways (known as landscape format)?

All of these alternatives need to be considered when you start to prepare your composition and you will find that it is worthwhile spending some time getting this right. A few quick thumbnail sketches are not only excellent practice, but they will save you a lot of time trying to correct compositions which, it soon becomes clear, are not quite right as you begin to draw and paint.

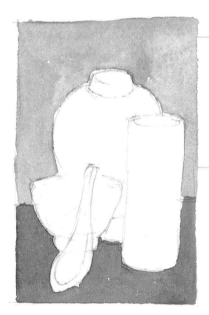

This upright (portrait) composition draws the viewer's eye very sharply into the centre gap between the tall pot and the dish, creating a real centre to the composition. The tall vase against which the objects are viewed will need careful painting as it will have the shadows of several objects cast onto it.

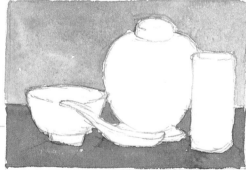

The lengthways (landscape) composition provides several visual 'breaks' where gaps occur between the objects. I find that this simplifies the shading on the objects, but the surface on which they are standing will need much closer observation.

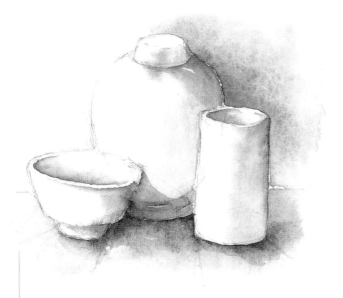

A small study of two objects situated together can help you to establish the direction in which certain things should be facing – forwards, sideways, or a back view.

This quick watercolour study helped me to sort out which shapes sat well together and which would not look quite right.

This ginger jar proved to be a valuable object to study before embarking on a composition of all-white china. Observing the direction of the light and shade helped considerably.

A cool spring day can be a true inspiration to artists, or an excuse for staying firmly planted indoors in the warmth and comfort of your home. I noticed these tulips laid out on a nearby market stall on my way home one morning and decided that they would make an irresistible subject for painting. The freshness and clarity of their colours and the contrasts between the reds and greens seemed almost to 'sing'.

A white milk jug to hold the flowers seemed to catch and reflect the cool, blue light shining through the French doors in the room where I usually paint. To complement these, and to avoid the composition becoming too fussy, a few more white objects were placed around the jug. The white kept the composition visually simple, allowing the greens from the tulip leaves to stand out. All of these items were then positioned on a pine table, which acted as a solid, slightly warm base on which the group of objects was securely set. When you set up your still-life group you might also like to consider the direction of the light and shadows as this can make a great change to the overall feeling of your picture.

A tonal study in pencil, planning the direction of the light and subsequent soft shadows, can be useful.

A study in pencil of the shadows only will help considerably when you start to paint the table top.

28 x 27 cm (11 x 10½ in)

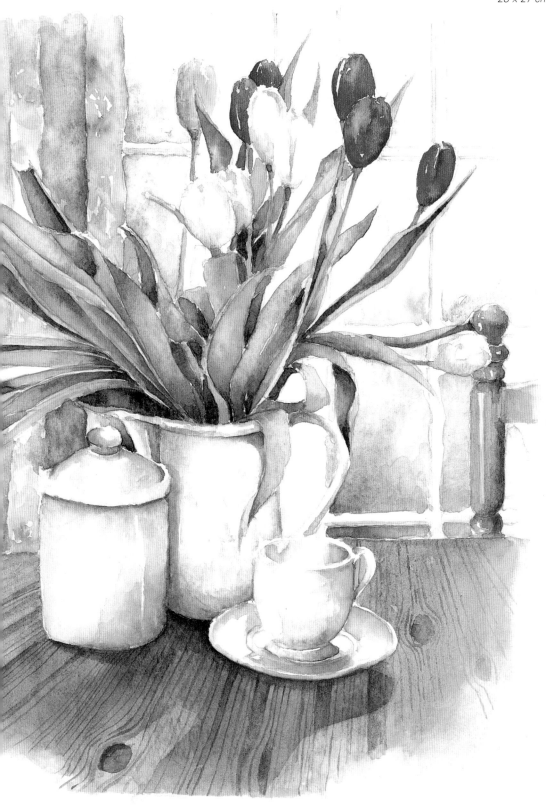

Spring can be a season of sharp, still frosts when the early morning sun glistens and sparkles on rooftops and roads alike. But, as many of us who have been deceived by a little sun and ventured out unprepared know, it can also be a season of gales, storms and unexpected showers!

The study of this rural cottage with crisp sheets drying on the washing line epitomized the strong gusts and squalls that can so frequently occur, and I felt compelled to make a sketch as a personal reminder of my rambling follies. As the wind picked up, the washing began to dance on the line, folding and wrapping and twisting itself into knots. This needed to be recorded quickly with a few quick dashes of paint, leaving much white paper to glow against the stormy sky on the horizon. The sky itself was a fascinating mixture of tobacco tones and cold greys, changing by the minute as the storm grew closer.

But the key to this scene was the movement. Nothing was still! The grass, the sheets, the clouds all seemed to be alive and the pace was increasing as the storm grew. The feeling of movement was suggested by ensuring that all brush strokes moved from bottom left to top right, diagonally across the paper, as quickly as possible.

The sky was painted with a mixture of Prussian Blue with a touch of Burnt Umber washed liberally onto damp paper. The areas of cloud were created by 'blotting out' with a sheet of scrunched-up kitchen roll. Before they dried fully I treated them to a very watery wash of Raw Sienna to remove the whiteness. Then, before the areas of sky behind the clouds could dry, a little Alizarin Crimson was touched in to aid the stormy feel.

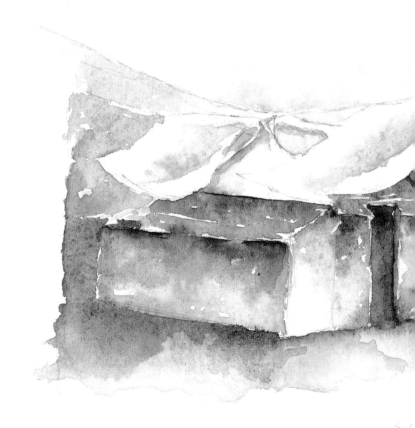

Spring Shadows in the Landscape
16.5 x 28 cm (6½ x 11 in)

The shadows on the sheets were created by painting a slightly diluted mixture of the sky colour onto dry paper and allowing it to dry. The scene was quick and sharp, and the hard lines of the shadows seemed appropriate.

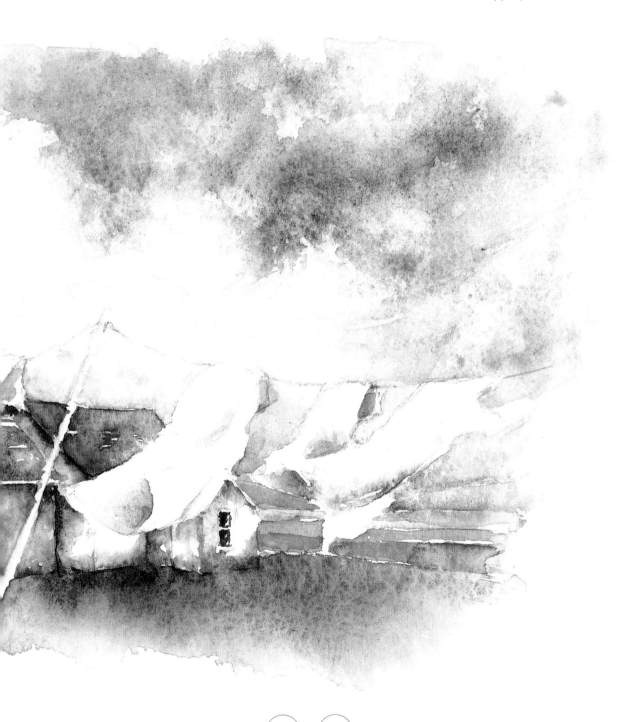

1

The first stage in painting this cool spring landscape was to wash in the sky. To do this, I dampened the entire sky area, waited until the surface water had soaked in, then applied a wash of Cobalt Blue to the area above the main clouds, pulling the paint in the direction of the scudding softer clouds.

2

The next stage was to create the furthest background. As distant hills will always have a blue tint, I mixed a watery combination of Cobalt Blue and Sap Green and, working onto dry paper, painted the background hills in layers, making sure that each 'layer' was a little more pronounced than the one behind.

3

The middle ground appeared lighter than the distant hills and trees, creating a visual sandwich between the background and foreground. The thinner mixture of the previous background wash was 'dragged' across the paper, making sure that the broken brush strokes allowed a few flashes of white paper to show through.

The tree and the more immediate bushes were treated to an underwash of Burnt Umber, Sap Green and Cobalt Blue, and left to dry. This would be the colour that would be painted onto with broken brush strokes, allowing this underwash to show through as the lightest of colours.

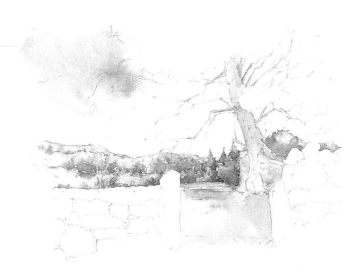

5

Having established the tones of the middle ground, a certain level of detail had to be added through colour, rather than line and shape. A succession of watery colours – Cobalt Blue, Sap Green, Burnt Umber – were applied to the rock outcrop using a small brush, allowing them to mix freely by bleeding and blending.

6

This technique was also used on the tree trunk, allowing pure colours to mix on the paper, rather than creating contrived mixes in a palette. A stronger mixture of Burnt Umber and Cobalt Blue was applied to the right-hand side of the tree trunk to increase the shaded effect.

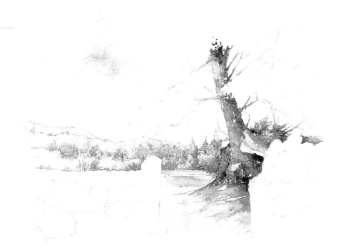

An element of warmth was introduced by adding a little Lemon Yellow to the Sap Green. This was washed loosely across dry paper using a medium size brush, allowing little flashes of white paper to show through. The darker areas were mixed with Sap Green, Burnt Umber and Cobalt Blue, using a small brush.

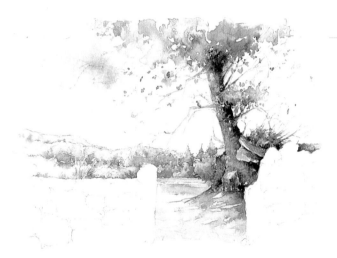

The feeling of movement was created by dabbing assorted mixtures of Lemon Yellow and Sap Green at the very edges of the branches, leaving some visually 'floating' to give the effect of loose leaves being borne on the spring breeze.

The foreground was warmed up by applying a wash of Lemon Yellow and Sap Green across the paper, pulling the paint downwards across both the immediate middle ground and the area in front of the stone wall.

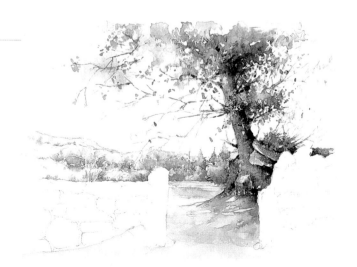

10

For the dry stone wall a watery wash of Raw Sienna was applied to damp paper. As this was drying, strong mixtures of Cobalt Blue and Burnt Umber were dabbed into the darker areas and allowed to bleed freely. When the damp paint had dried, the same mixture was used to 'draw' a few of the stone shapes onto the variety of tones, using a small brush.

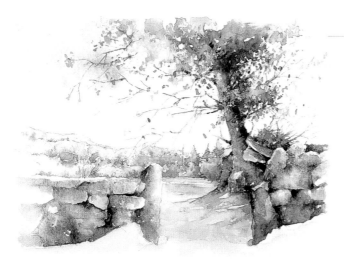

11

As this process of drawing with a brush continued across the wall, a few touches of Burnt Sienna were introduced to add a touch of warmth to the stonework. Most of the really dark shaded areas were applied at the base of the wall, enhancing the feeling of weight and solidity.

12

Finally, the dappled foreground spring shadows were added with a strong, yet watery, mixture of Sap Green and Cobalt Blue. Using a medium size brush to achieve a good, quick coverage, the paint was applied in a diagonal direction, painting around the underwash in places to create highlights.

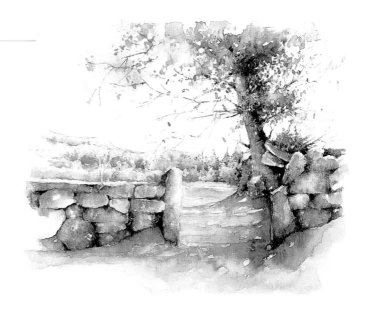

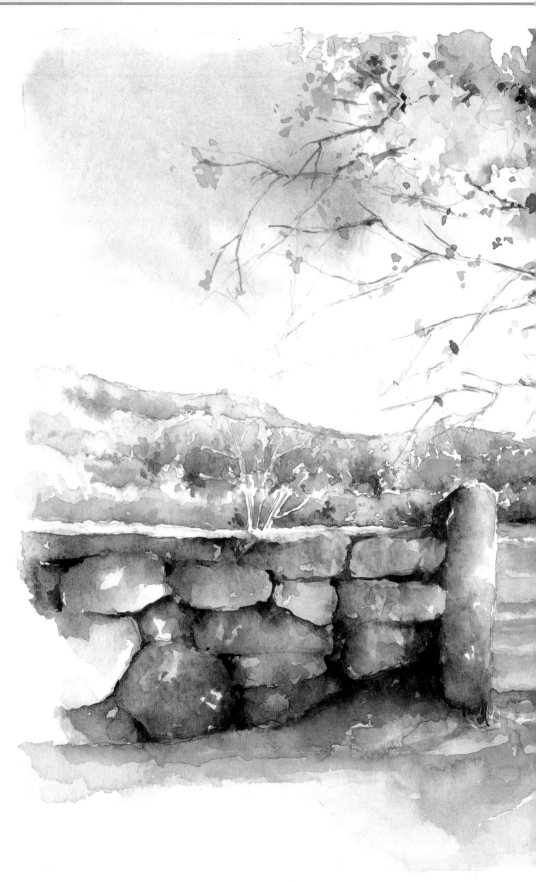

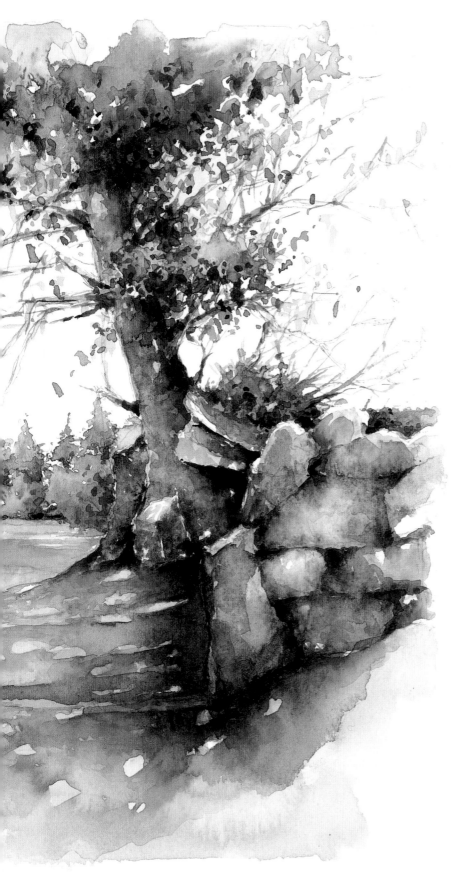

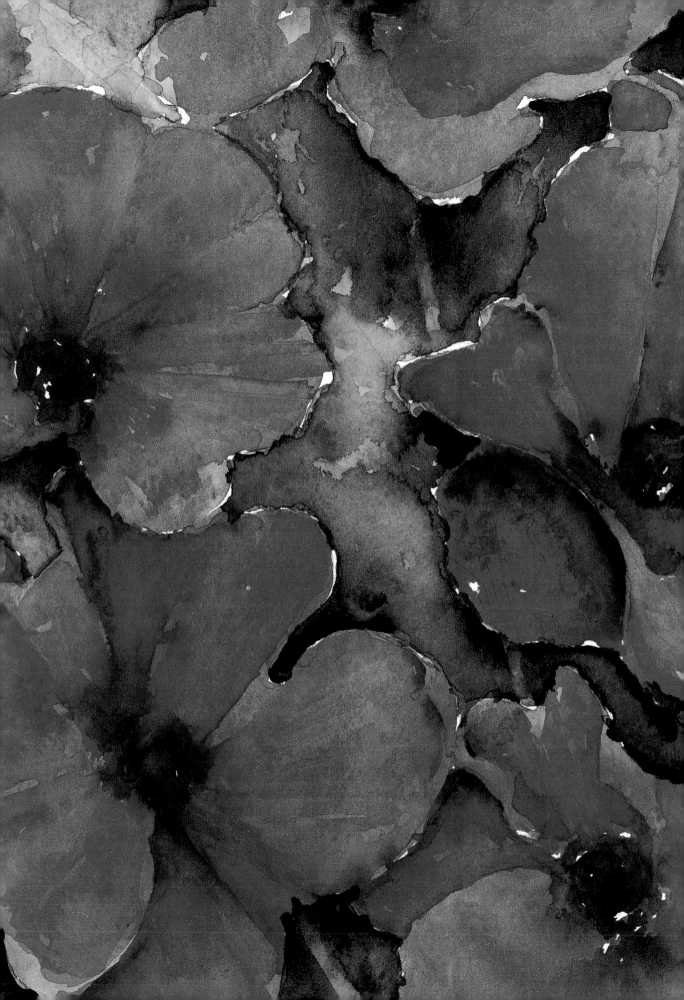

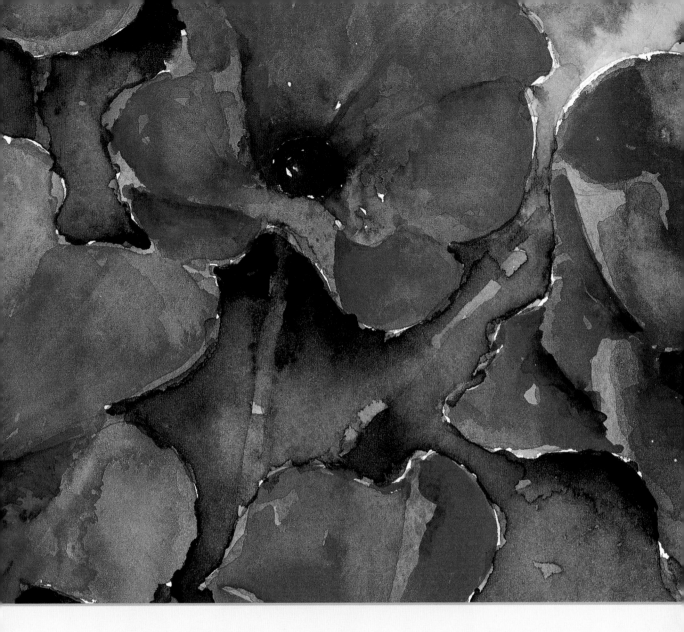

THE HEIGHT OF SUMMER

The rich, vibrant colours of the height of summer can be captured in few better forms than the wild poppies that grow in fields, gardens and hedgerows. The striking contrast of the bright reds and the deep greens create a sensation for the eyes that few man-made creations can, and the deep purple centres to the flowers only add to the sumptuous image.

summer

Summer is a time when the most vibrant of colours can be used freely. Bright red geraniums and terracotta pots are natural allies, complementing each other perfectly – they both hold the warmth of the summer sun and share a strong red colour base. Equally, the violet- and purple-coloured shadows cast onto peach-tinted, sun-kissed stone also have their place in the summer painter's palette and can be used with equal vigour.

Remember that shadows will be a combination of colours from the many varying aspects of the scene being painted – a touch of terracotta roof colour mixed in with the strong blue of the sky, for instance, will help to create the colour and the tone of shadows. French Ultramarine is a good, general-purpose warm blue that mixes well with all colours and forms the basis for shadows, skies, trees and ground colours.

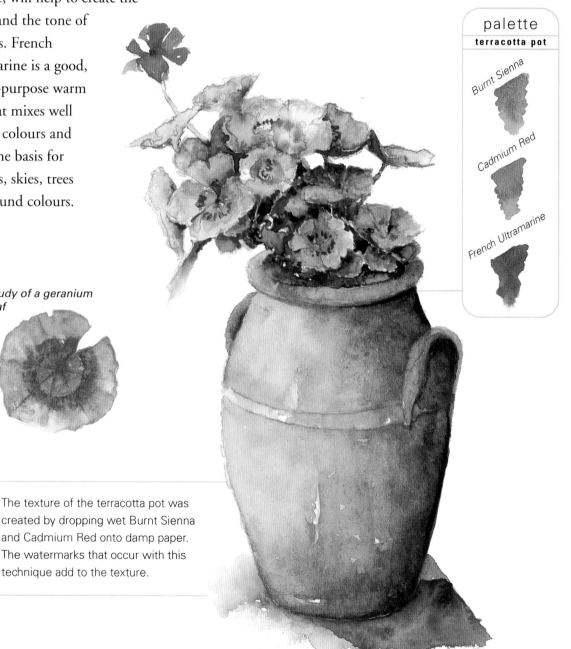

palette
terracotta pot

Burnt Sienna

Cadmium Red

French Ultramarine

Study of a geranium leaf

The texture of the terracotta pot was created by dropping wet Burnt Sienna and Cadmium Red onto damp paper. The watermarks that occur with this technique add to the texture.

key colours

The key colours of any summer palette are chosen for their strength and vibrancy. Summer is usually a time when pure colours can often be detected in highlights and shadows, and these key colours are ideal for recording them.

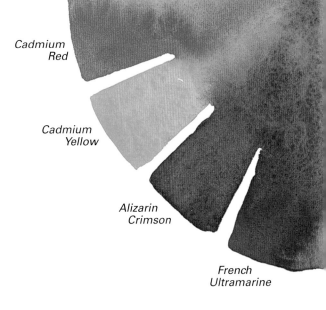

Cadmium Red

Cadmium Yellow

Alizarin Crimson

French Ultramarine

palette
nasturtium leaf

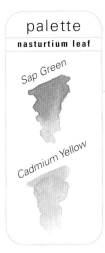

Sap Green

Cadmium Yellow

Study of a nasturtium leaf

The nasturtium flower was created by using a lot of water and a lot of paint, dropping Cadmium Yellow onto wet paper, and adding Cadmium Red as the surface water dried.

The deepest greens in this study were created by mixing Sap Green and French Ultramarine.

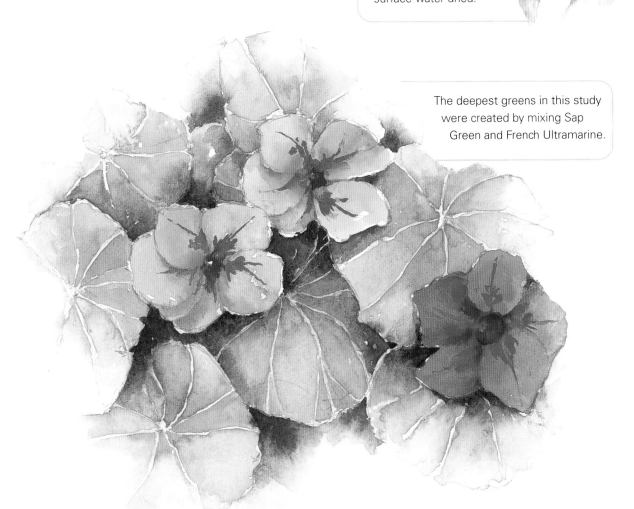

The long days of summer provide plenty of opportunities to take your sketchbook out with you. Use it to make quick sketches of anything that catches your interest, or to record particular details for future reference.

The linear qualities of pieces of old, weather-worn, sun-bleached driftwood make them a fascinating subject to draw, while the lines of seashells and detailed strands of seaweed found at your feet on the beach are an equal delight for the artist. Even a watercolourist sometimes has to accept that colour is not always required in a sketchbook study and that, occasionally, the desire to simply draw with a pencil becomes irresistible.

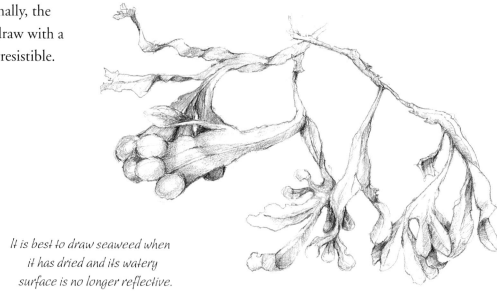

It is best to draw seaweed when it has dried and its watery surface is no longer reflective.

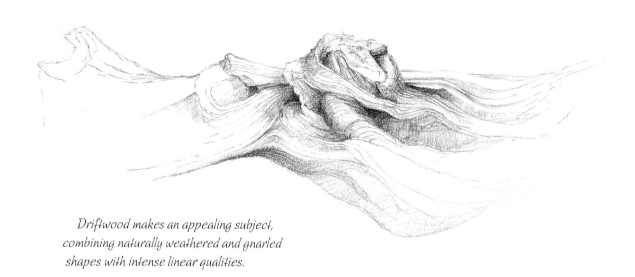

Driftwood makes an appealing subject, combining naturally weathered and gnarled shapes with intense linear qualities.

Do not be wary of being experimental with your sketches. Spattering paint helped to create the texture here.

The light string stood out against the dark glass of this lovely old fisherman's weight, making it a challenging subject to study.

Sometimes nature helps you by creating a design. This 'string' or line of shells is one such example.

With a sketchbook you can be much more mobile and seek out places to draw where fewer visitors tend to wander. The far end of the beach, away from the deckchairs, can hold a wealth of subject matter. The detritus from the fishing industry, the weather-worn shells and the blackboard signs from the quayside restaurant here were so redolent of a warm summer's day spent on the seashore that I just had to record them on an ozone-laden sketchbook page. Texture in discarded fish makes an ideal watercolour subject – many of these textures can be recorded by dropping assorted blues and greys on damp paper and allowing the paint to bleed freely. Once this is dry you can pick out a few details with a fine brush. The ceramic tiles surrounding the blackboard rely upon characteristic seaside blues.

After looking at this shell from all angles, I decided that this side was the most interesting to draw.

Note that the darkest shadows are inside the shell. I used these as the starting point for the sketch.

Just a few visual notes to help me recall the subject later.

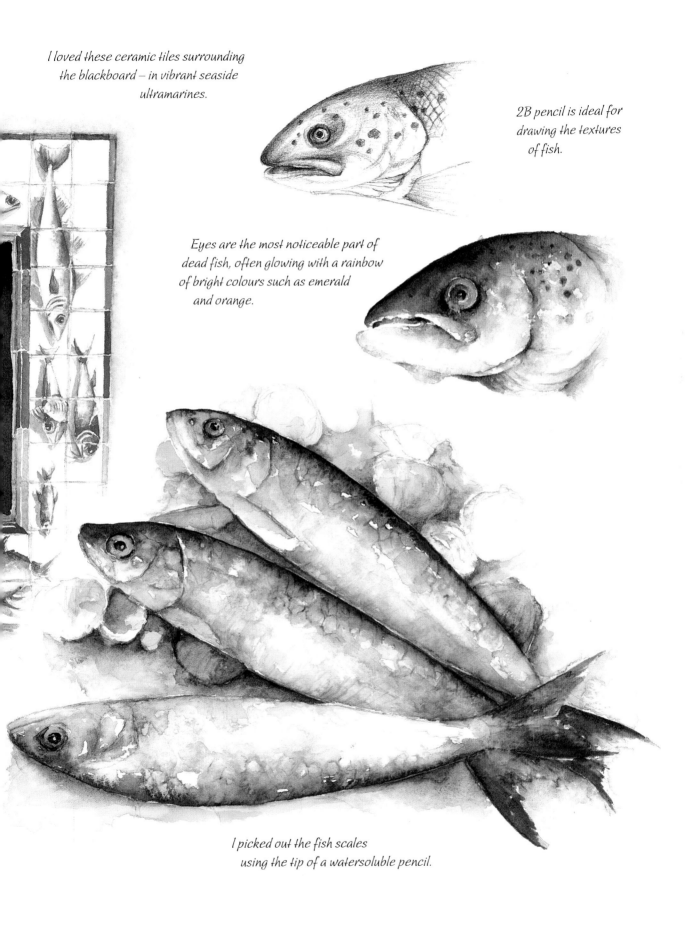

I loved these ceramic tiles surrounding the blackboard – in vibrant seaside ultramarines.

2B pencil is ideal for drawing the textures of fish.

Eyes are the most noticeable part of dead fish, often glowing with a rainbow of bright colours such as emerald and orange.

I picked out the fish scales using the tip of a watersoluble pencil.

This technique requires the liberal use of much water and paint. First make sure that the paper is very wet. Then, as soon as the surface water begins to evaporate, and a wet 'sheen' is evident on the paper, apply the first wash of colour freely with no concern for an even coating. The more uneven the coverage of paint, the better the end result will be. Then, before this wash has dried, apply another colour to the paper. This will bleed gently onto the damp paper.

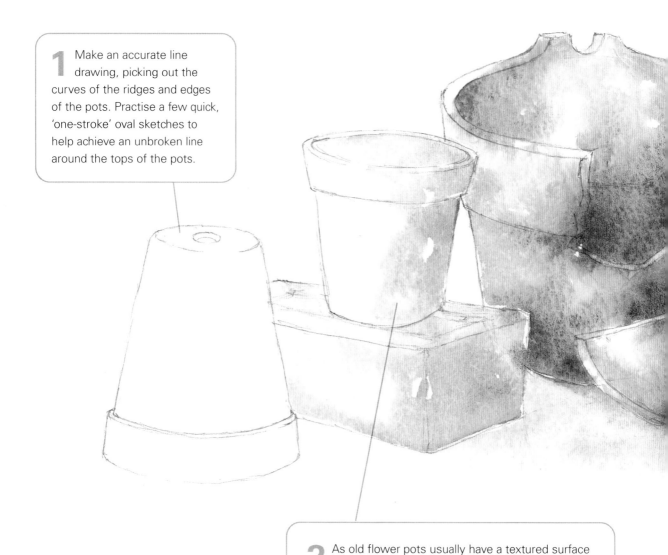

1 Make an accurate line drawing, picking out the curves of the ridges and edges of the pots. Practise a few quick, 'one-stroke' oval sketches to help achieve an unbroken line around the tops of the pots.

2 As old flower pots usually have a textured surface there is no need for a smooth, even covering of paint. The more uneven it is, the more effective will be the result, so work very quickly using broken brush strokes, applying a wash of Raw Sienna. Then add more wet paint onto the existing wet paint.

3 When you start to add the darkest colours (Burnt Umber and French Ultramarine) it is important to avoid the areas where the light will catch, on the edges and ridges. At this point change from a medium brush to a small one to allow more control over the spread of paint. Still continue to apply the paint wet onto a wet surface.

The individual surface character of this terracotta pot was achieved by blending several colours wet-into-wet.

4 Finally, paint onto dry paper to avoid any bleeds and to create a sharp, crisp edge to the pots. Use purple or violet shadows to enhance the sense of warmth.

SUMMING UP

Wet-into-wet is a technique that can really make the most of textured watercolour paper. The free application of paint and the random bleeds that occur also add a feel of spontaneity to your pictures.

Painting these sunflowers involves using a brush technique known as stippling. With stippling you can create the wealth of orange, yellow and brown tones on the inside of the sunflower heads. The technique uses the tip of the brush only and the paint is applied onto dry paper with a rapid dabbing action, allowing you to achieve a range of darker yellows and oranges. On the sunflowers the colours are applied in a circular motion, radiating out towards the outer edge, where a brown paint is introduced to describe the darker, shaded parts. Stippling is best practised with a small, cheap brush as it will eventually start to spoil the tips of expensive brushes.

1 When drawing sunflower heads, always look for the stray petals that are either forced back, or fall across the flower head, to give interest.

2 Use an even mixture of Lemon Yellow and Cadmium Yellow as an initial wash, making a 'balanced' colour that is neither bright nor dull.

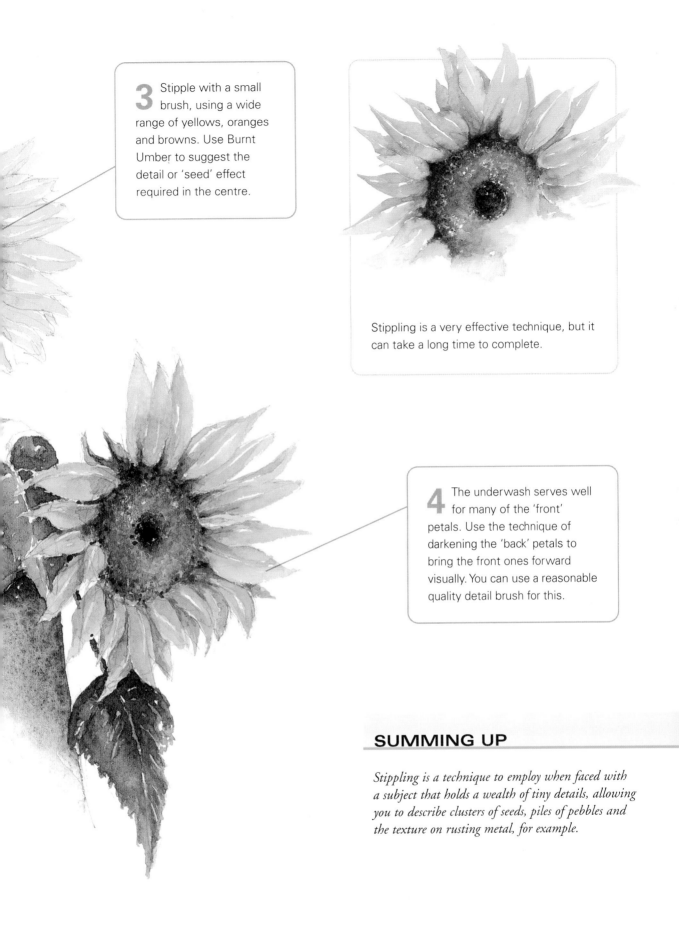

3 Stipple with a small brush, using a wide range of yellows, oranges and browns. Use Burnt Umber to suggest the detail or 'seed' effect required in the centre.

Stippling is a very effective technique, but it can take a long time to complete.

4 The underwash serves well for many of the 'front' petals. Use the technique of darkening the 'back' petals to bring the front ones forward visually. You can use a reasonable quality detail brush for this.

SUMMING UP

Stippling is a technique to employ when faced with a subject that holds a wealth of tiny details, allowing you to describe clusters of seeds, piles of pebbles and the texture on rusting metal, for example.

Wet-into-damp differs from wet-into-wet in that you can use this technique once all of the water has evaporated and only the fibres of the paper are damp. This results in a smaller area of bleed occurring around the point of contact between paintbrush and paper, and a more controlled effect. The colours will still bleed together when applied next to each other, but the area painted in this way may well have a slightly softer edge when it dries.

1 When painting a subject such as a flag, where pattern or 'lines' are an important feature, always try to make a quick line drawing first. This will act as a structure upon which the colour can be added.

2 For the first wash, always establish the basic colours in 'flat' form, working onto damp paper.

3 To strengthen and darken the areas in the folds of the flag increase the depth of the colour. Usually the addition of a little French Ultramarine or Violet to the actual colour (even if it is white) will suffice, painted onto damp paper. This will bleed, but only gently.

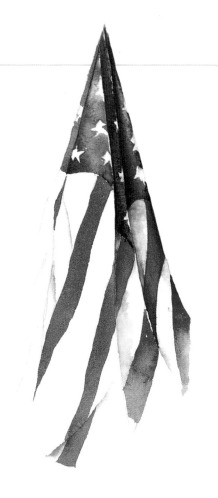

The folds of the 'Stars and Stripes' flag all fell in one downward direction, making them easier to record.

SUMMING UP

Wet-into-damp requires as much awareness of your paper as of your subject. Wait until the surface water has been absorbed before applying your paint.

Although the summer months are usually fine and warm, it is certainly not uncommon for overcast or dull days to occur. Nor is it unusual for downpours of rain to wash out plans for a painting expedition. When these occasions arise you may find it useful to have a supply of still-life props handy so that you can compose a group of objects to paint in the warmth and comfort of your own home.

For centuries artists have used geometric shapes as the basic structure for their compositions. A triangle is a useful shape with which to experiment. Try placing a selection of seaside objects so that they sit in a near straight baseline, and lead the viewer's eye to the peak at the top. Your triangle need not necessarily be a regular shape, of course. The angles at the base can vary, or the baseline could even dissect the picture plane at any angle you choose. As always, it is important to try out several combinations before you commit yourself to paint.

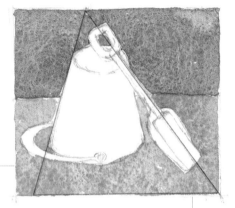

The shape of this triangle is irregular, with the main line of the composition following the spade, which is resting against the bucket (itself creating a near triangle when turned upside down).

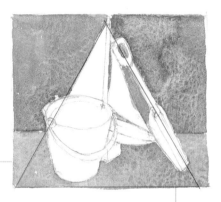

This regular triangle encompasses, and visually 'contains', all of the objects in the picture frame. The plastic spade is leant against the yacht (which itself forms the centre part of the composition) to reinforce the triangular shape.

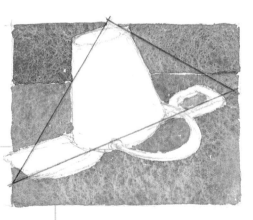

The baseline of this triangle cuts diagonally across the picture frame, creating a less passive and more visually dynamic composition.

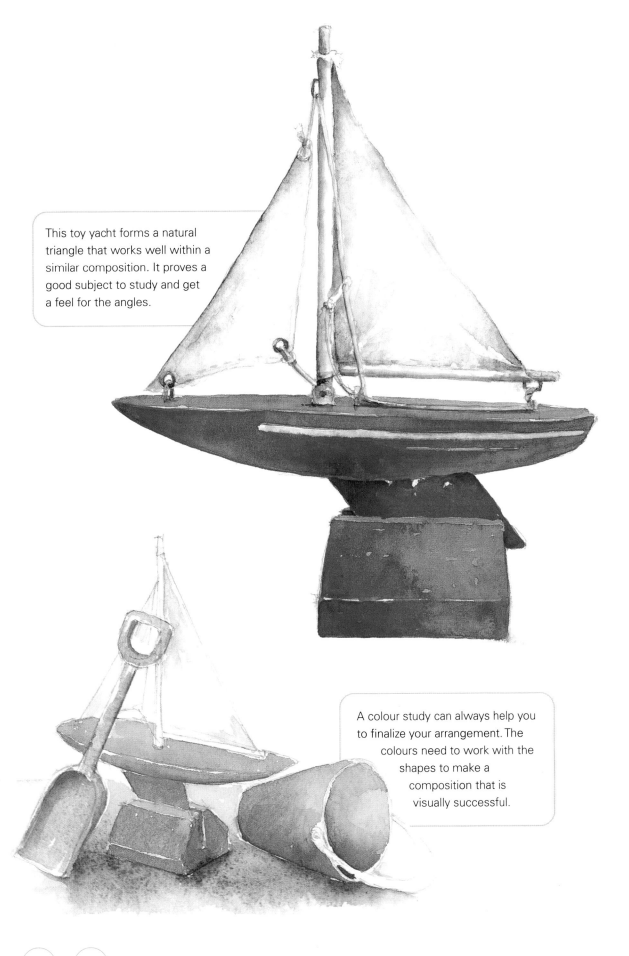

This toy yacht forms a natural triangle that works well within a similar composition. It proves a good subject to study and get a feel for the angles.

A colour study can always help you to finalize your arrangement. The colours need to work with the shapes to make a composition that is visually successful.

A set of beach paraphernalia found stored in a bag left over from a previous beach trip was spread out onto a towel and arranged with the ball in the centre. This allowed the toy yacht and the spade to be positioned either side of the ball, supporting each other and preventing the ball from rolling. These objects also formed a triangular shape, which is always a visually pleasing way to set up a still life.

It is always a good idea when setting up a still-life group, especially when using curved objects, to make sure that they will remain where you put them. Try fixing them with tape or reusable adhesive.

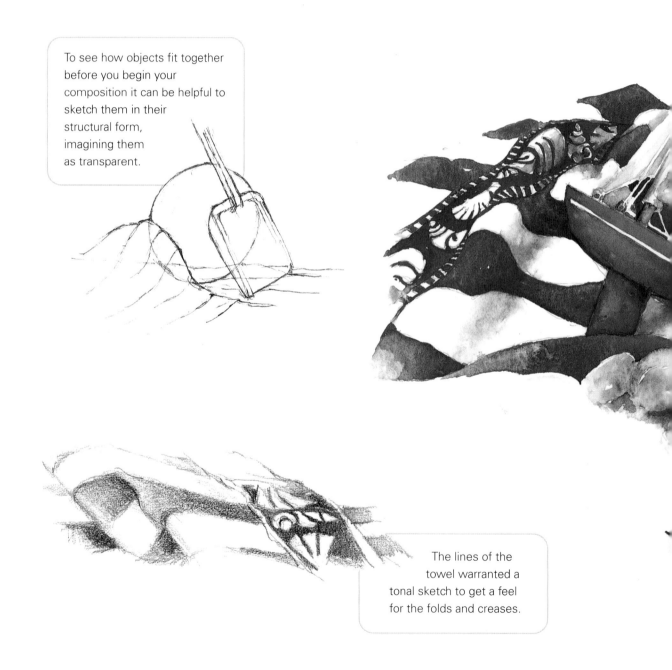

To see how objects fit together before you begin your composition it can be helpful to sketch them in their structural form, imagining them as transparent.

The lines of the towel warranted a tonal sketch to get a feel for the folds and creases.

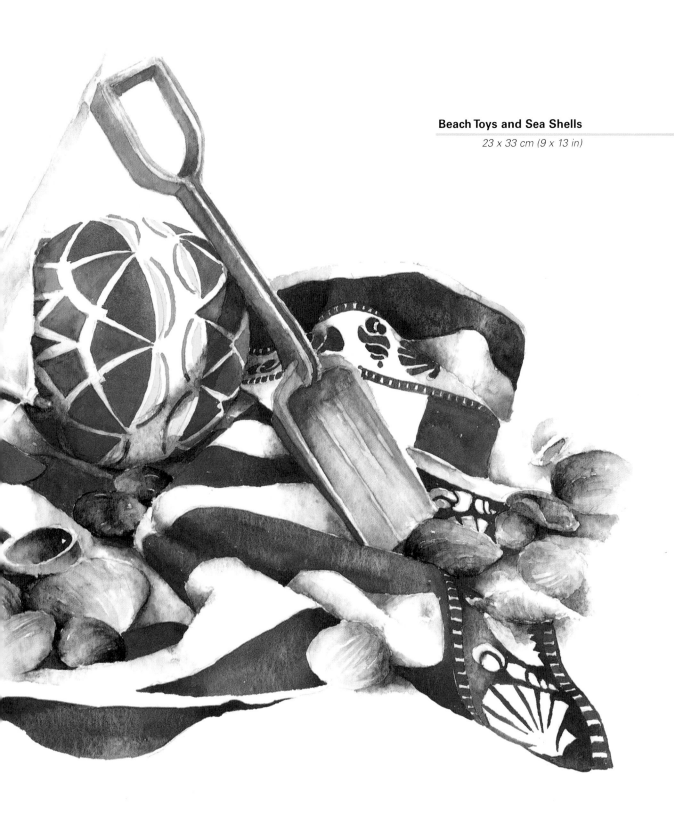

Beach Toys and Sea Shells
23 x 33 cm (9 x 13 in)

Summer is by far the best time for painting the wealth of greens found in a garden, as well as the bright colours of the summer flowers. It is also a good time to watch and paint other artists at work. The depth of the green in the darkest areas of foliage in this painting was created by using a three-part mixture of Sap Green, Hooker's Green (which has a strong blue bias) and French Ultramarine. This deep, cool green with its blue base proved to be an ideal complement for the soft violet colours of the flowers. The deep tones also visually thrust the white flower heads forward, as well as establishing the figure painting in the middle ground of the composition. Small areas of white paper serve to suggest both movement in the foliage and a sense of reflection.

Using exactly the same principle of allowing the darkest tones in the background to push the lighter tones forward, the foreground was painted to achieve this visual 'push–pull' effect. These lighter tones were emphasized by the use of Sap Green mixed with Cadmium Yellow.

The summer flowers that provide the flashes of colour were painted after the lush greens had dried. If bright colours are added to damp paint they will invariably bleed – a two-way process that consequently leads to muddied colours that have lost their intensity. The colours of summer flowers do not last for long, and need to be retained in all their vibrant glory.

Artist in the Summer Sun
18 x 24 cm (7 x 9½ in)

The notion of light and shade was emphasized by applying the paint to dry paper with broken brush strokes, allowing little flecks of white paper to show through.

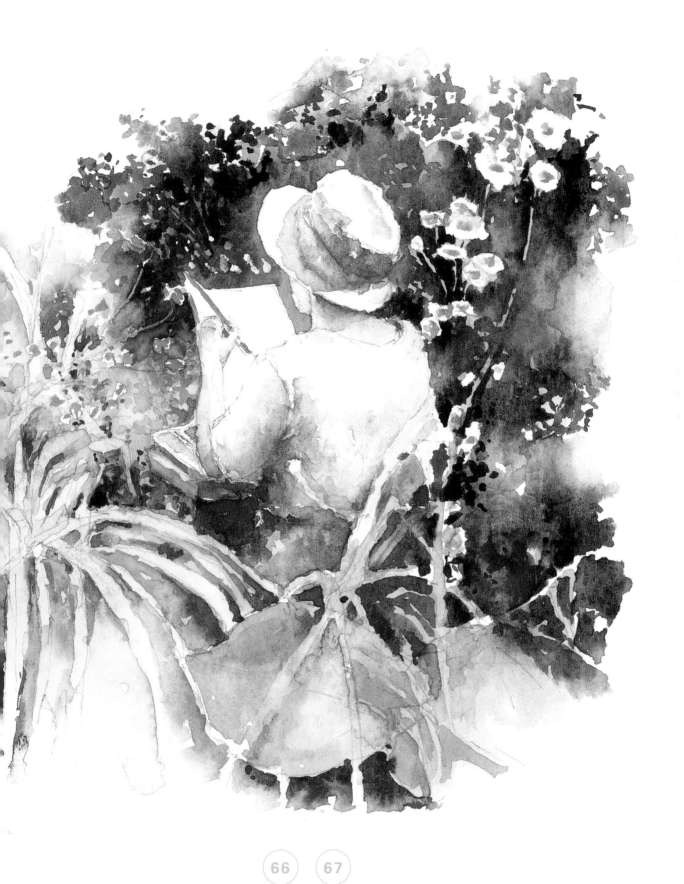

1

A single wash of French Ultramarine was applied to the sky area, being careful to paint around a few of the leaves that had been drawn. These leaves would be painted later, and it was necessary for them to remain unaffected by a blue underwash. The wash was quite easy to control as the area of sky to be painted had first been dampened with clear water. When the paint was applied it ran only onto the wet areas, and did not bleed onto the dry leaf shapes. The wash was then left to dry.

2

The background foliage was given an underwash mixture of Sap Green and French Ultramarine, using a medium brush. Since this part of the picture would be the furthest visible distance, these trees would reflect a higher level of blue light. While the underwash was still damp I began to create the shaded areas around the base of the trees. I did this by applying a darker mixture of the same colour, but with more blue added, using a small brush.

3

The next 'layer' of trees were a brighter colour, which I made by adding some Cadmium Yellow to the Sap Green and Ultramarine mixture. This, again, was darkened towards the base by applying a dark green mixture of paint onto a damp underwash with a small brush.

4

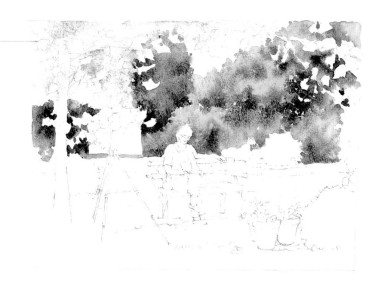

The background row of trees, bushes and shrubs was completed by following the procedures in steps 2 and 3 across the width of the composition, reinforcing the idea of visually bringing lighter colours or tones forward by painting darker colours or tones immediately next to them. Even though the day was dry and hot, the background still needed to hold a blue tint, with suggestion of foliage rather than any real detail.

5

When the paper had dried, a very dark green mixture was used to create the shapes of the clumps of leaves and foliage catching the light by almost drawing the shadows underneath and beside them. The very deepest areas of shadow were treated in this way.

6

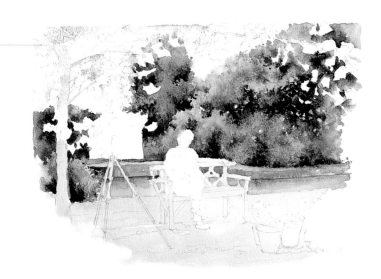

In the middle ground the initial wash for the grass and pathway was painted onto wet paper to allow the paint to spread and flow into the damp paper. This method of application usually prevents the creation of brush strokes as the paint dries, allowing an even surface. The grass was then painted using a mixture of Raw Sienna, Cadmium Yellow and Sap Green. The path was painted using pure Raw Sienna to give a feeling of warmth to the ground.

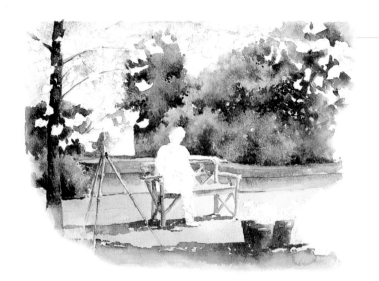

7

With the middle and background established, I could start to develop the foreground. First, I washed in the shapes of the shadows that were vital to suggest the strength of the sun on this bright summer's day. The shadows were created by mixing French Ultramarine with Alizarin Crimson. This mixture was applied by loading a medium size brush with paint and dragging it outwards from the source of the shadow. This had the effect of graduating the shadow where it naturally weakened.

8

The terracotta pots, painted with an underwash of Raw Sienna, followed by a liberal application of Burnt Sienna, needed to be visually separated by the application of dark shadows. These shadows were created by painting a very strong mixture of French Ultramarine and Alizarin Crimson onto the sides of the pots that were hidden from the light. This was allowed to dry as a dark block of paint rather than graduating the colour.

9

The shadows that fell on the artist's clothes had to balance visually with the shadows on the ground – that is, they had to share the same strength of tone. The French Ultramarine and Alizarin Crimson mix complemented the soft violet clothes of the artist, and these shadows were painted into the depths of the folds and pulled out in the direction of the shadow across the body.

Finishing touches were made in the immediate foreground features of the bench, artist, easel, pots and shrubs. Geranium leaves and bright Cadmium Red flowers were painted in the pots. The feel of deep, strong midday shadows was reinforced by darkening the foliage next to the pots with lots of French Ultramarine.

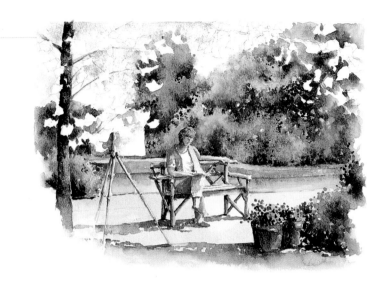

11

The overhanging leaves on the right side of the composition were painted in darker tones than the background to create a sense of balance, light and shade throughout the entire composition. The blank leaf shapes on the left were painted last.

12

The leaf shapes on the left were painted a lighter tone than the colour behind them, creating the feeling that the leaves are hanging or rustling in the gentle summer breeze on one side of the composition. The paint used for these was a mixture of Cadmium Yellow with a touch of Lemon Yellow and Sap Green applied to dry paper.

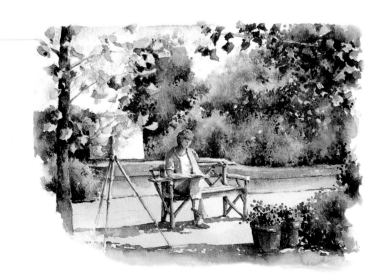

THE TURNING OF THE YEAR

The yellows, reds, oranges, ochres and siennas of the turning of the year are best sought on the forest floor. While the golden glow of trees in the fall is a true delight to witness, the leaves that fall randomly on the ground are by far the most interesting to the artist. Where nature is at work order and chaos become one.

autumn

Autumn is a season of rich natural colours, with fields harvested and ploughed to reveal deep brown umbers and trees and forests aglow with siennas, oranges and reds. It is the natural earth pigments – siennas, umbers and ochres – that are the key to recording the rich variety of autumnal colours. Use these paints, along with some of the more artificial oranges, scarlets and reds to mix a wealth of reds, oranges, yellows and browns. Even the sky can be awash with colour, frequently containing Raw Sienna and Alizarin Crimson (two of the warmest of colours).

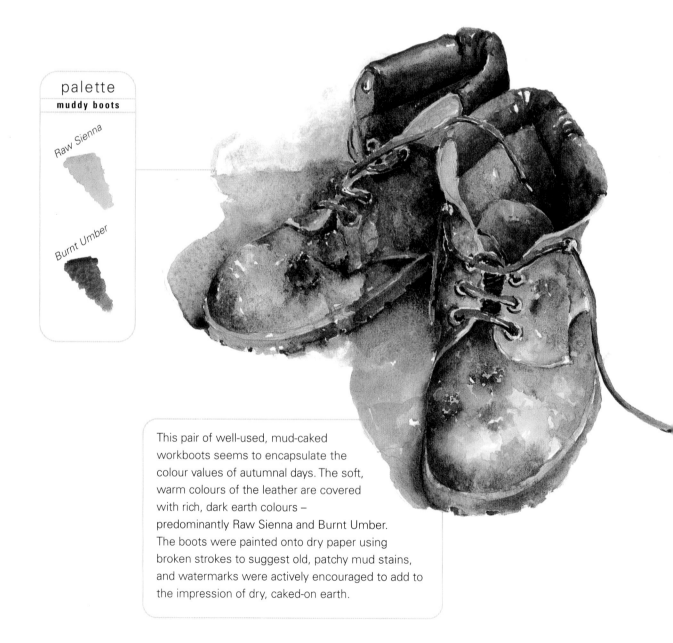

palette
muddy boots

Raw Sienna

Burnt Umber

This pair of well-used, mud-caked workboots seems to encapsulate the colour values of autumnal days. The soft, warm colours of the leather are covered with rich, dark earth colours – predominantly Raw Sienna and Burnt Umber. The boots were painted onto dry paper using broken strokes to suggest old, patchy mud stains, and watermarks were actively encouraged to add to the impression of dry, caked-on earth.

key colours

The key colours of autumn are selected for their natural qualities. The 'earth' colours are so called because they are created from mineral deposits and therefore owe their very existence to the earth. They are rich, deep colours that are ideal for capturing the essence of the season.

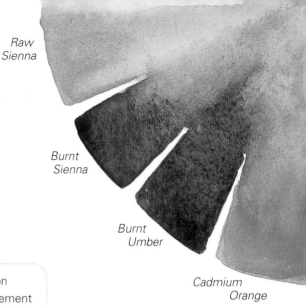

Raw Sienna

Burnt Sienna

Burnt Umber

Cadmium Orange

The rust and mud stains on this old trowel complement each other perfectly.

I found this old, rusting tractor an irresistible subject to paint, bringing back warm memories of harvest time as a child. The once-yellow machine was covered in a wealth of rich rust tones, all painted with mixtures of Burnt Sienna, Burnt Umber and a little French Ultramarine. The sharp angles of this wonderful machine were created by leaving the white of the paper as highlights.

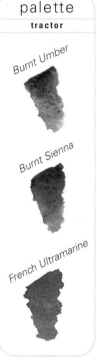

palette
tractor

Burnt Umber

Burnt Sienna

French Ultramarine

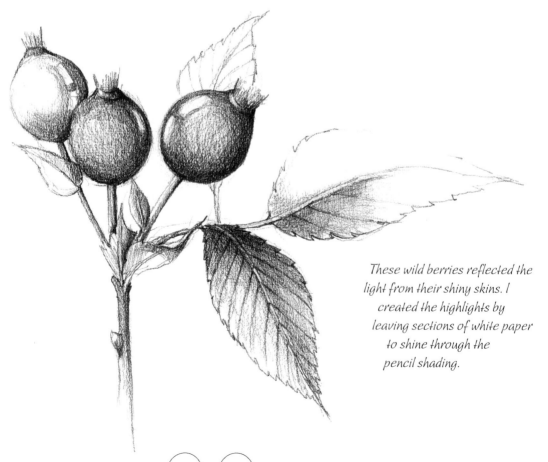

A walk across open countryside, or a trip to your nearest farm shop at the turning of the year will provide a wealth of subjects for sketchbook studies. A few berries, some dried seedheads, a handful of freshly dug vegetables or several grotesquely misshapen gourds and squashes will provide ample material for many hours' drawing and sketching.

The connections between most of the natural objects collected here for sketching is that they share a slightly distorted circular shape, and look all the more interesting for their peculiarities.

I used a circular drawing motion to record the textures on these carrots. The leaves were more complicated to draw, but just as interesting.

These wild berries reflected the light from their shiny skins. I created the highlights by leaving sections of white paper to shine through the pencil shading.

Delicate shading was required for these highly ornate dried seedheads. I used the edge of the pencil lead in a circular motion to create the bulbous shapes.

The curved surface of both the mushroom and the onion required highlights and shadows, but one needed a smooth treatment and the other a linear one.

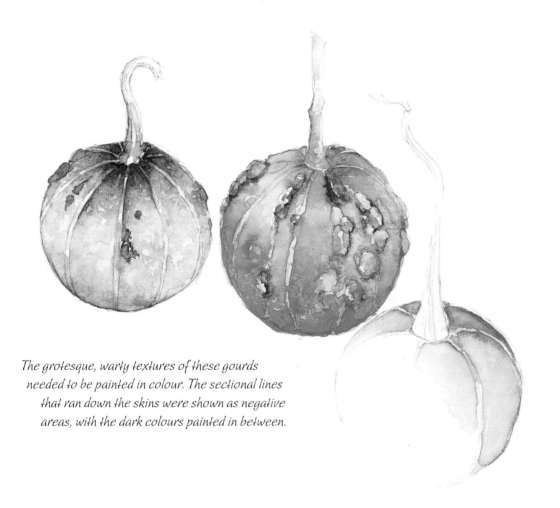

The grotesque, warty textures of these gourds needed to be painted in colour. The sectional lines that ran down the skins were shown as negative areas, with the dark colours painted in between.

You can often find the most distinctive and richest colours of autumn in the market stalls or, on occasions, hanging from a tree. Pure reds, oranges and yellows are to be caught in the natural products of the harvest.

Sometimes colour can be overused, with no feeling for light and shade, so it is important to add a few highlights. All of the studies on these pages required leaving small flashes of white paper to create the effect of highlights.

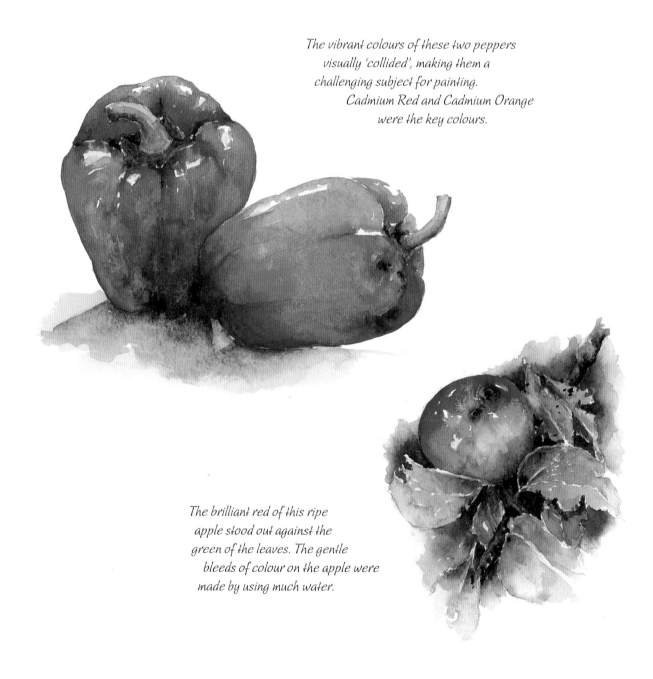

The vibrant colours of these two peppers visually 'collided', making them a challenging subject for painting. Cadmium Red and Cadmium Orange were the key colours.

The brilliant red of this ripe apple stood out against the green of the leaves. The gentle bleeds of colour on the apple were made by using much water.

I 'drew' this corncob with paint. The linear qualities of
the leaves and the small corn kernels required me
to use the paintbrush almost like a pencil.

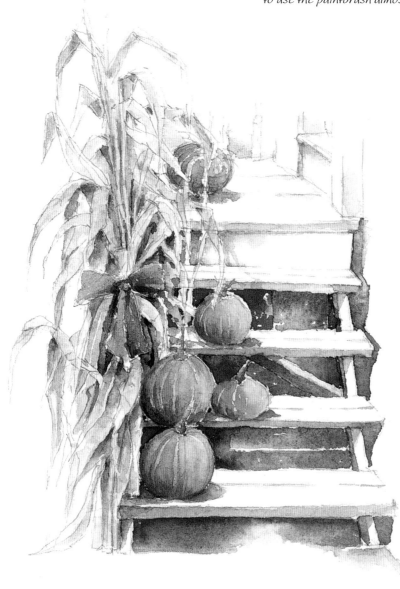

'Dressing' the steps to houses
with corn sheaves is a
wonderful North American
custom. The Raw Sienna of
the corn complemented
the orange of the pumpkins
perfectly.

Y ou need to create a wealth of tones to paint foliage. Capturing the reflections of trees and bushes is a challenge that is best met by using a lot of water with your paint. Many of the main tones can be mixed on the palette, but the softer tones are better achieved by mixing on the paper as wet-into-wet bleeds.

The tones of greens mixed on the palette rely heavily upon the quantities of paint added. Sap Green makes a good base colour. By adding touches of Cadmium Orange and Burnt Sienna you can alter the tone of the green completely, giving a new and much more natural colour. Be careful not to add too much orange or brown, however, or the green will be 'neutralized' and the resulting colour will look dull and muddy. The mixed tones will change once again when a little water is added to them on the paper.

1 After making a very simple line drawing, apply an underwash consisting of a watery mixture of Raw Sienna and Sap Green to the damp paper along the background hills. This will create a range of different tones as the paint dries.

Geese are migratory birds and are often to be found around lakes and rivers before the cold winters begin.

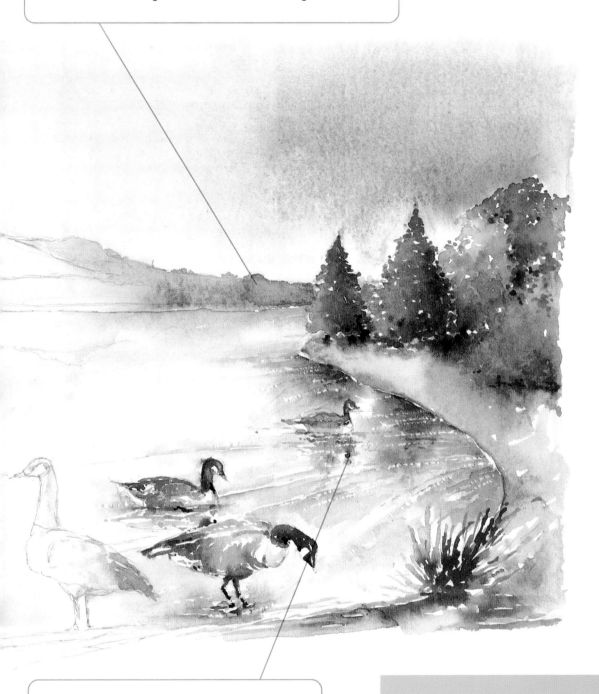

2 Mix some of the autumnal oranges and siennas with some Sap Green and paint this onto the existing underwash. The colours will blend to give an even more varied range of tones.

3 The soft tones found in the reflections in the water are similarly built up. Add slightly stronger mixes to the already established underwash. The damp paper allows bleeds to occur, diluting and diffusing the tones, so creating another set of new tones and colours.

SUMMING UP

Tones can be created through mixing colours and creating subtle differences, or by diluting the strength of the mixture by the addition of more water.

One of the key aspects of creating textures is finding a suitable subject in the first place. Old, gnarled wood, weather-beaten fences and brambles are ideal starting points. Creating textured pictures involves using the qualities of watercolour paper by allowing the natural construction of the paper to enhance your painting. One of the best ways of achieving this is by flooding a sheet of strong, textured paper with watery paint. Then, just as the paint is starting to be absorbed into the paper, fairly vigorously blot the sections where you want a textured appearance with a sheet of scrunched-up kitchen roll. This action forces the watery paint deep into the fibres of the paper, leaving the imprint of the textured paper on the surface.

Blackberries can add an unexpected flash of colour amongst the wild brambles.

1 Textured subjects such as areas of undergrowth, where ageing and decay has taken place, will often require a detailed line drawing. Having established this, wash a very wet mixture of paint across the entire area. Begin the blotting process right from the outset as soon as the paint starts to be absorbed – you will notice that the reflection from the surface water starts to fade and a sheen develops on the paper.

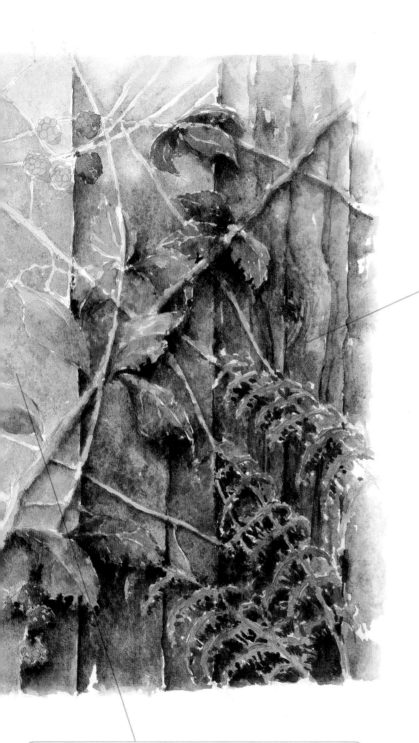

3 Finally, use the naturally occurring textured areas on your paper and enhance them with more considered and accurate paintwork. Knots in wood, for example, can be created by painting a few lines to represent the grain around the textured section. A few dabs of watercolour paint into the centre of textured parts can create the impression of rusting nails or rotten holes and crevices.

2 Once the first blotting action has been completed you can enhance the effect with further blotting. When several layers of texture have become established and the water and paint have dried into the fibres of the paper the textures will start to take on a life of their own.

SUMMING UP

Textures can be recorded through the use of tone and colour, but can actually be created on your watercolour paper by the vigorous use of kitchen roll.

Masking is a technique that involves covering sections of watercolour paper with masking fluid, masking tape, or any other waterproof substance to prevent any of the subsequently applied paint making contact with the paper. When the masking substance is removed a hard-edged area of plain white watercolour paper will remain, which can be left as highlight or painted as required.

There are a few dangers surrounding this technique. First, it is vital that you do not remove the masking substance until the paper itself is totally dry. Even though the paint may be dry the fibres of the paper may still be damp, and removing the masking at this stage can result in the edges around the white shape smudging. Another problem is that some masking substances are not compatible with some papers. Occasionally, when the tape or fluid is removed, the surface of the paper will come off with it, often removing surrounding pieces in the process.

1 Carefully isolate the shapes to be masked – the best way to do this is usually by drawing. Apply masking fluid to the shapes using either an old brush or a twig or small stick. Masking fluid will ruin the hairs of a brush after several applications, so only use one that is worn out or of no value for any other painting. Leave the masking fluid to dry.

2 Apply paint to the picture in the natural way, simply washing across the masked areas. If you apply too much paint, you will find that some will accumulate around the raised surface of the masking fluid and dry to a darker tone. This effect is not necessarily always unwanted, however, as it will reinforce the lightness of a masked shape.

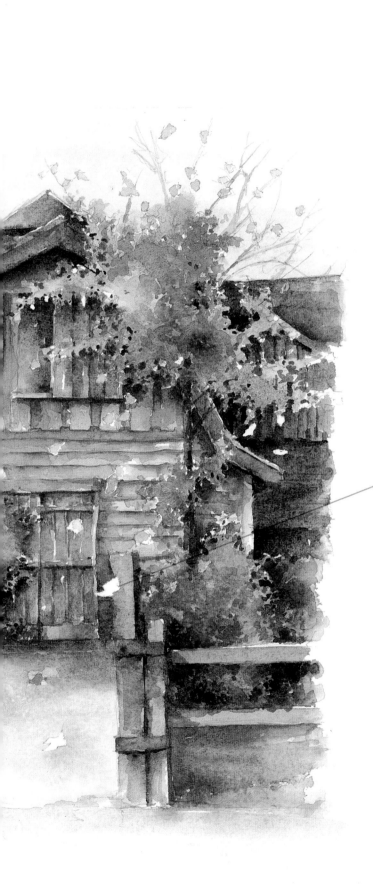

Small single objects such as leaves with delicate veins make good subjects for practising the application of masking fluid.

3 Very few objects or features that you wish to paint will be pure white, but masking them allows you to keep them lighter than their surroundings. Once the masking fluid has been removed, you will probably want to paint the white shape a light colour or tone.

SUMMING UP

Masking should really be limited to a few small areas that need to remain white. The smaller the masked area, the easier it will be to remove the masking medium.

A collection of breads, rolls and produce provides a challenge to organize into a suitable composition for a painting. While all of the individual subjects are visually interesting in their own way, some planning is required to make the most of the various shapes. Clearly the objects cannot be positioned one on top of another, so the obvious solution is to place them in a row or line.

Deciding the relative positions of each object in the row takes further thought. Something has to be placed in the centre of the row to provide a point of focus, although this could just as easily be a space as an object. Spaces can be valuable elements in a painting if you wish to avoid visual clutter or a dull line of unbroken continuity.

This composition divides the picture frame into one-third and two-thirds blocks, using the tallest object, the wicker basket, as the focal point. Visual tension is created along the line of the group as the eye is drawn almost out of the picture to the far left-hand side.

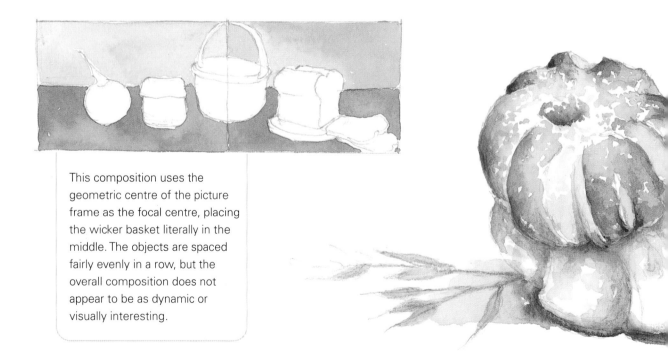

This composition uses the geometric centre of the picture frame as the focal centre, placing the wicker basket literally in the middle. The objects are spaced fairly evenly in a row, but the overall composition does not appear to be as dynamic or visually interesting.

Even the positioning of small objects can be vital to the overall impact of a composition. It is always as well to experiment with angles – should the loaf of bread be facing towards or away from the centre of the composition, for instance? As always, a quick sketch will help you to decide.

It is sometimes a good idea to try to create a composition with different sized and shaped objects to test the visual dynamics. This collection of bread rolls seemed an appropriate subject with which to experiment. The space on the left-hand one-third works well.

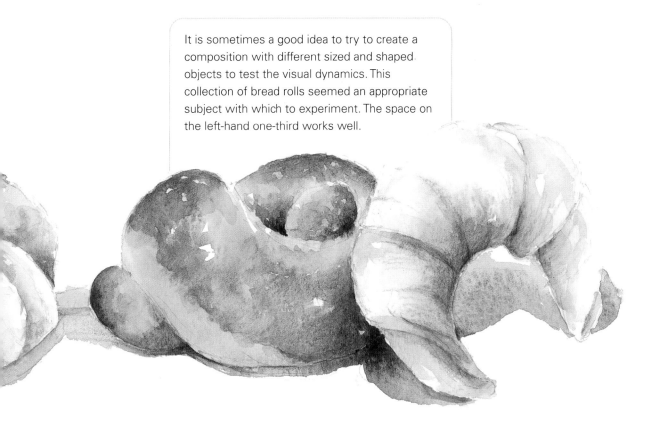

This table-top study of bread and produce needed a visual anchor to hold it together, yet at the same time this had to prevent the component parts from looking as if they were actually connected. Adding the tablecloth proved to be just right for the composition. The lines lead the viewer's eye from the immediate foreground, past the line of the objects and through to the space behind them. The folds and creases in the foreground are arranged to create a 'V' shape along the front line of the composition. The tablecloth was also chosen for its visually binding colour. Linking by colour can be as important to a composition as the size and shape of the objects themselves.

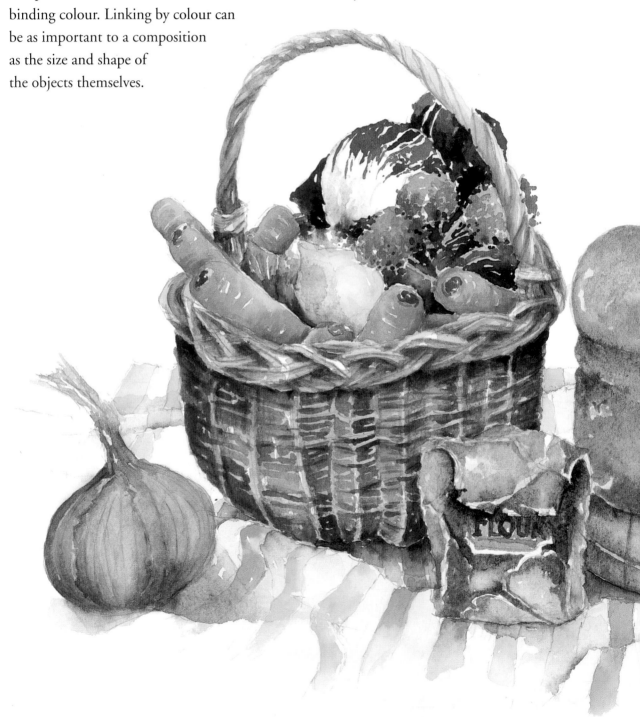

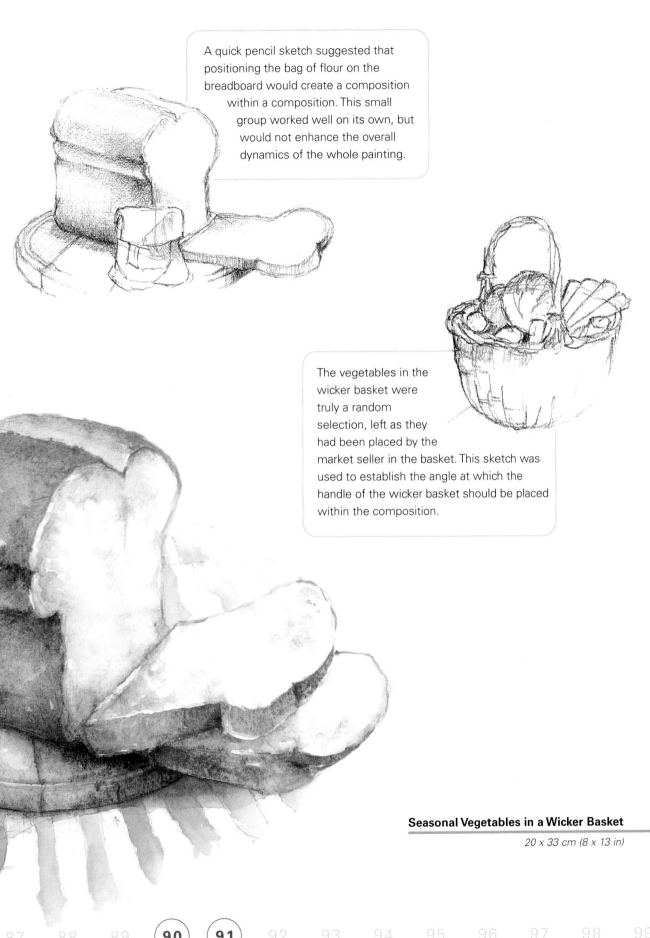

A quick pencil sketch suggested that positioning the bag of flour on the breadboard would create a composition within a composition. This small group worked well on its own, but would not enhance the overall dynamics of the whole painting.

The vegetables in the wicker basket were truly a random selection, left as they had been placed by the market seller in the basket. This sketch was used to establish the angle at which the handle of the wicker basket should be placed within the composition.

Seasonal Vegetables in a Wicker Basket

20 x 33 cm (8 x 13 in)

Leaves make wonderful subjects to study when assessing the colours needed to paint a series of trees or a forest. They are microcosms of colour and hold most of the tones that you will see in an entire scene.

Forests and woodlands may be the first choice for artists who want to use trees as a source of inspiration, but vineyards, too, hold a variety of autumnal-coloured leaves. A study of grapes on the vine offers a wide range of colours, tones and shapes, and studying such a subject will certainly equip you to tackle a larger forest scene, especially with regard to colour awareness. The complexity of the shapes, with branches and twigs cutting across the leaves in front and behind, echoes the visual structure that you are likely to encounter when faced with a forest or woodland scene. In this painting a visual 'push-pull' effect of leaves appearing to stand in front of other leaves was produced by darkening the paint behind the individual leaves, making them appear lighter and more prominent.

The variety of tones (see Tonal Mixing on pages 82–83) were created by using Sap Green as the base colour and adding a range of touches of other colours, chiefly siennas, browns and yellows. These were then diffused even more by adding water at various stages of application.

Grapes on the Vine
22 x 25 cm (8½ x 10 in)

The subtle colours on the tips of the leaves were created by bleeding wet red and orange paint into the wet green paint of the leaves.

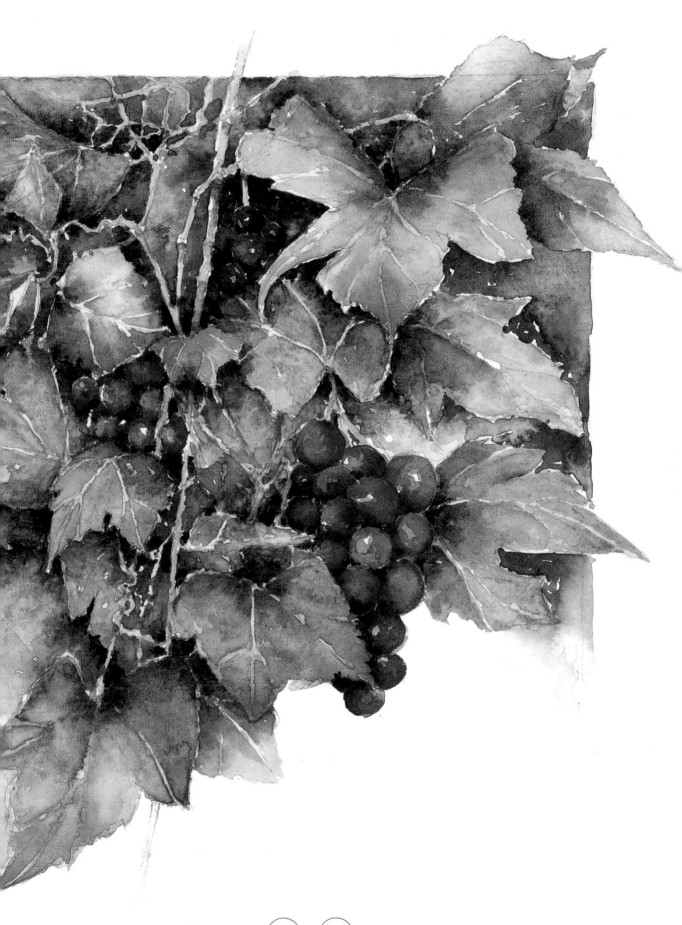

1

The branches of the composition were drawn and masking fluid was applied using a very old paintbrush. When this had dried the paper was dampened. An underwash of Cadmium Yellow and Raw Sienna was painted on and allowed to run and bleed freely onto the foliage areas of the composition.

2

Before the underwash had time to dry a watery mixture of Burnt Sienna was applied to selected areas and, again, allowed to bleed freely, so that it created its own shapes and forms. A medium brush was used for this.

3

The process was repeated several times across the line of trees, creating a range of new colours and tones as the paints ran and bled. These would become the middle tones and highlights that could be seen in the vast array of foliage.

4

Darker tones were mixed with an assortment of colours – Burnt Sienna, Burnt Umber, Sap Green – and applied to the base line of the trees while the paint was still damp. As the paint dried a slightly hard edge was created to illustrate the shapes of some of the trees.

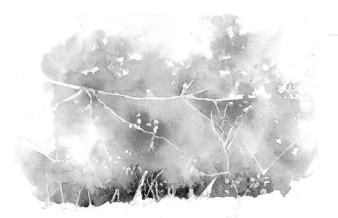

5

This approach was continued, spreading the paint across the visible horizon. The colours were deepened considerably in the centre to suggest a feeling of depth, and creating a visual passageway that you feel that you might be able to walk through.

6

The feeling of depth was enhanced by the addition of a mixture of Burnt Sienna and Cadmium Red. This was painted onto dry paper to create hard lines around the tree shapes in the upper part of the composition, using a small brush to allow more control.

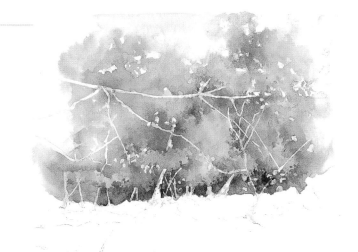

7

Wet-into-wet technique (see pages 56–57) was employed next to ensure the widest variety of tone and colour. A darker mixture of the colour was added to the paint applied in step 6, using the tip of a small brush, and allowed to bleed unhindered.

8

As the paint began to dry, a spattering technique was employed. This involved loading a small brush with a lot of watery paint, holding it 5 cm (2 in) or so above the painting, and firmly and sharply tapping the ferrule of the brush. This sent the paint spraying across the paper, creating little flecks of colour that look remarkably like leaves.

 9

Once the paint had dried thoroughly the masking fluid could be removed, leaving the sharp white paper exposed and creating some pleasing, almost ghostly, forms. Some of these could remain white.

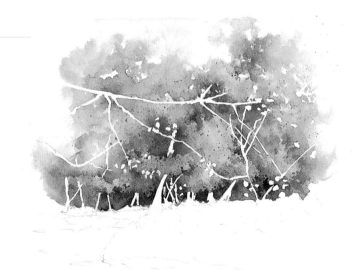

10

Many of the shapes, however, needed to be toned down by the addition of some watery paint. These were treated to an underwash of Raw Sienna. When this had dried a mixture of Burnt Umber and French Ultramarine was run along the edge of the trees to create a sense of form.

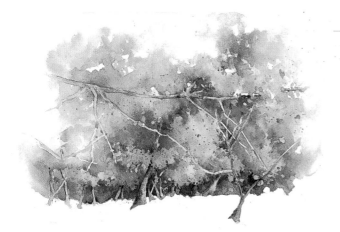

11

The intricate puzzle of light and dark trees and branches was completed in the same way, working across the composition. This involved constantly making decisions about which branch was standing out against others and adjusting the colour or tone accordingly.

12

The final stage of this autumnal woodland scene was to wash in the foreground. This was done by mixing nearly all of the colours in the palette. Working onto dry paper, I 'pulled' this paint mixture, using undulating strokes, across the line of the foreground, leaving a few broken patches to represent the light catching on the hillocks.

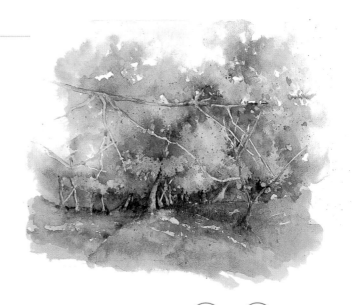

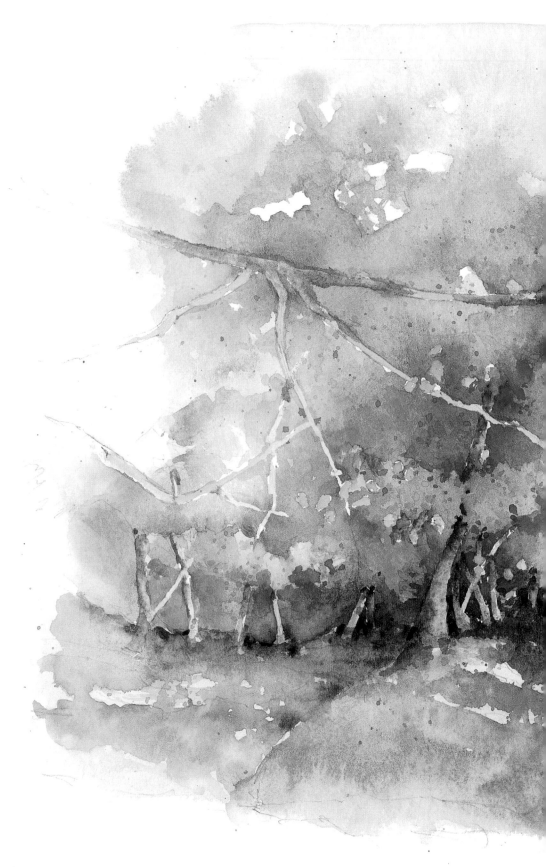

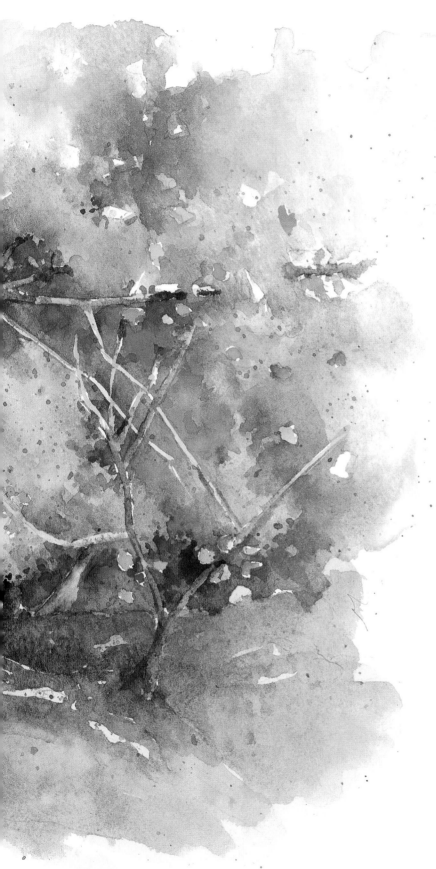

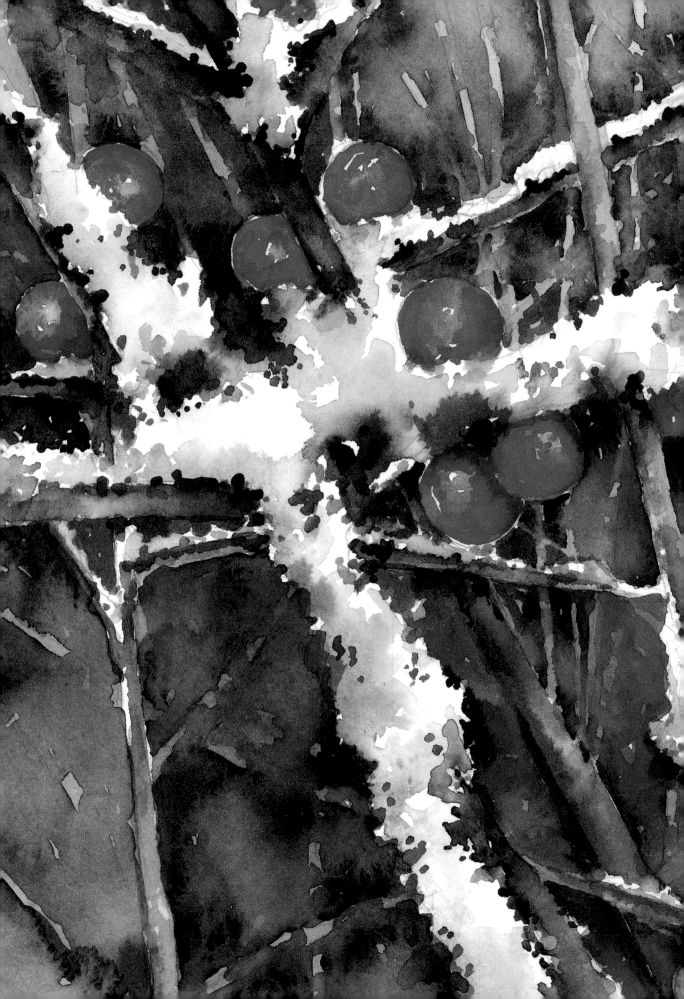

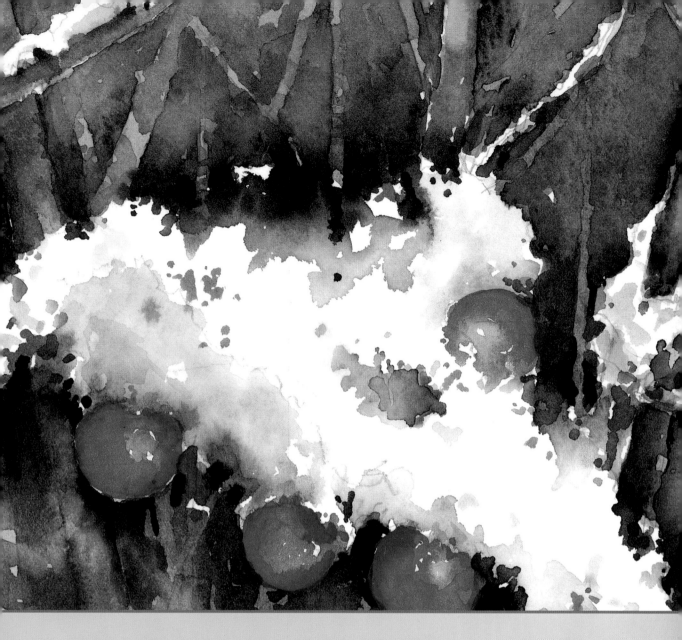

IN THE DEEP MIDWINTER

As the year draws to a close so the chill winds of winter bring snow and frost to settle upon the landscape. A new element is introduced for the artist to consider – white. As the bushes and trees begin to freeze, so the entire nature of the landscape changes. Bright colours become muted under a translucent frosted coating and we need to look again at the colours in our palettes.

winter

The colours of winter are, predictably, drawn from the colder end of the spectrum and Payne's Grey is a useful paint to employ as an additive. Cast shadows hold a cold tint and you will need to mix them with either Payne's Grey or one of the cooler blues such as Cobalt or Prussian. The natural greens found in the snow-clad fields and forests also tend to be bluish. The cooler greens, such as Terre Verte, Viridian and Hooker's Green, are useful and, as with spring, Cobalt Blue and Prussian Blue appear frequently in skies.

Instead of the warm earth colours, Yellow Ochre may be more suitable as it brings a certain cold quality to skies and the hard, frozen earth.

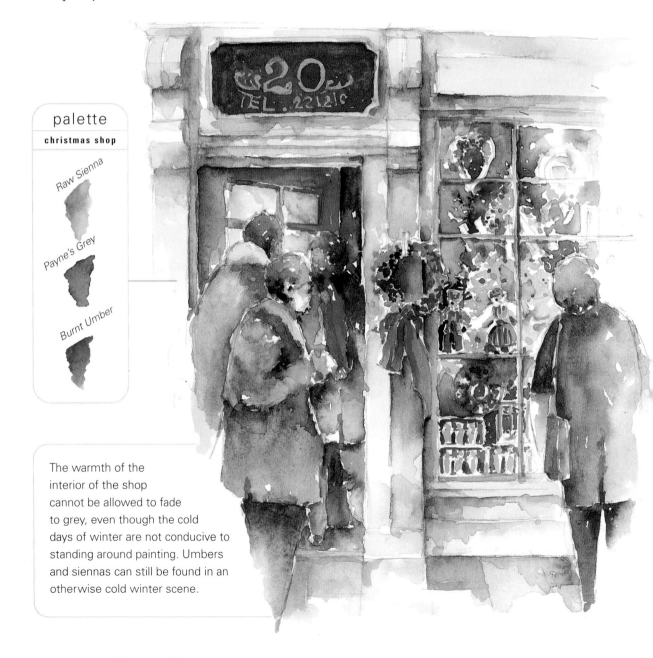

palette
christmas shop

Raw Sienna

Payne's Grey

Burnt Umber

The warmth of the interior of the shop cannot be allowed to fade to grey, even though the cold days of winter are not conducive to standing around painting. Umbers and siennas can still be found in an otherwise cold winter scene.

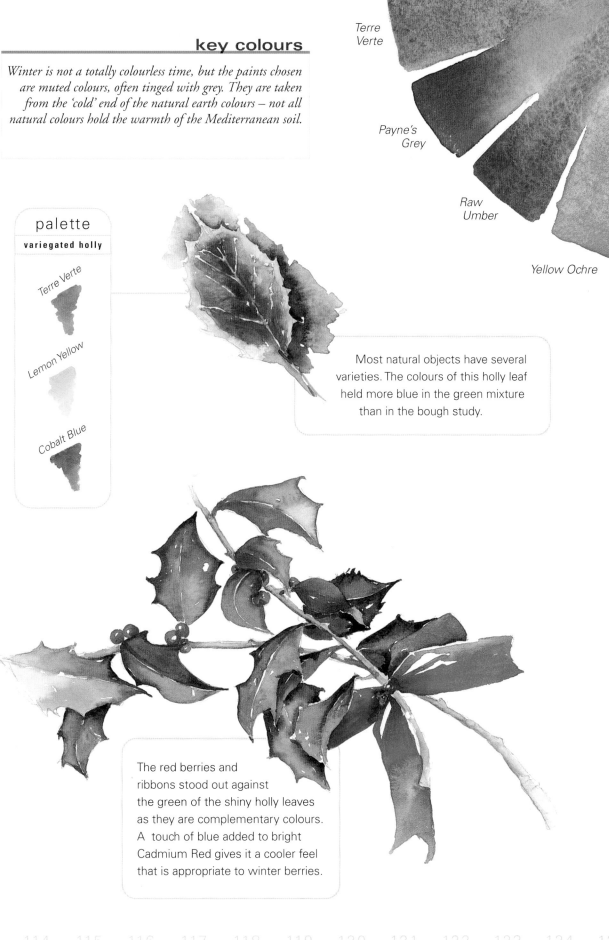

key colours

Winter is not a totally colourless time, but the paints chosen are muted colours, often tinged with grey. They are taken from the 'cold' end of the natural earth colours – not all natural colours hold the warmth of the Mediterranean soil.

Terre Verte

Payne's Grey

Raw Umber

Yellow Ochre

palette

variegated holly

Terre Verte

Lemon Yellow

Cobalt Blue

Most natural objects have several varieties. The colours of this holly leaf held more blue in the green mixture than in the bough study.

The red berries and ribbons stood out against the green of the shiny holly leaves as they are complementary colours. A touch of blue added to bright Cadmium Red gives it a cooler feel that is appropriate to winter berries.

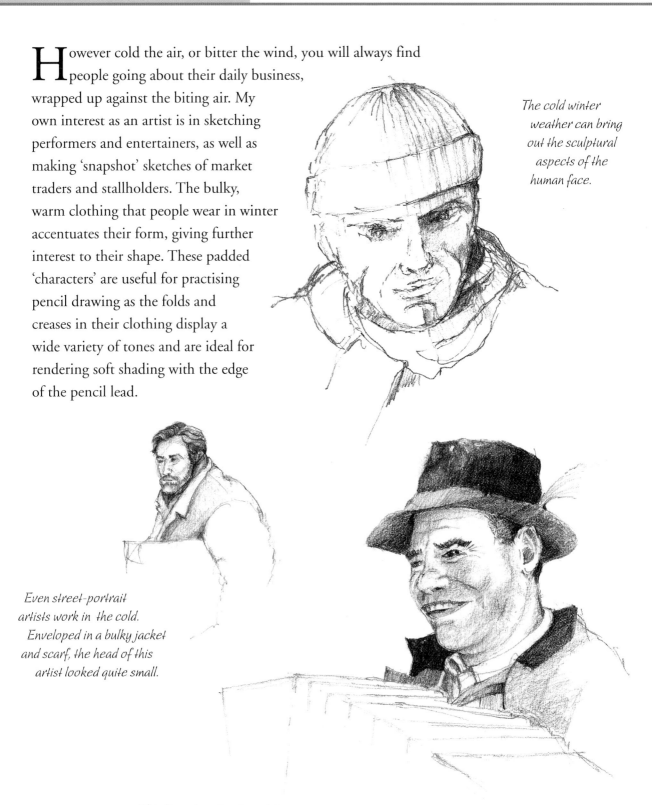

However cold the air, or bitter the wind, you will always find people going about their daily business, wrapped up against the biting air. My own interest as an artist is in sketching performers and entertainers, as well as making 'snapshot' sketches of market traders and stallholders. The bulky, warm clothing that people wear in winter accentuates their form, giving further interest to their shape. These padded 'characters' are useful for practising pencil drawing as the folds and creases in their clothing display a wide variety of tones and are ideal for rendering soft shading with the edge of the pencil lead.

The cold winter weather can bring out the sculptural aspects of the human face.

Even street-portrait artists work in the cold. Enveloped in a bulky jacket and scarf, the head of this artist looked quite small.

This Bavarian street musician had a ruddy complexion and sparkling eyes to match – ideal for shading practice on rough paper.

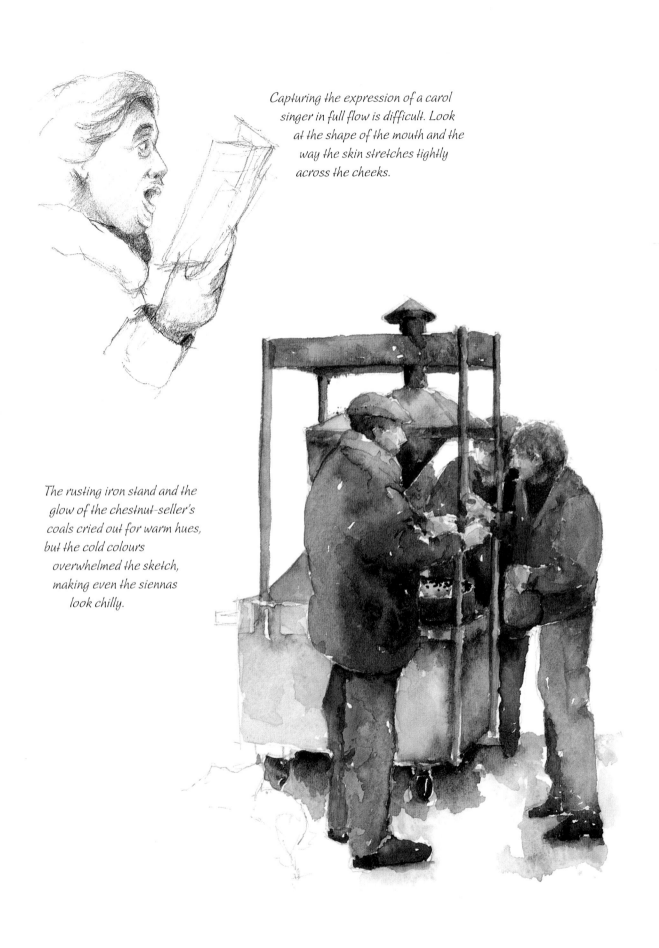

Capturing the expression of a carol singer in full flow is difficult. Look at the shape of the mouth and the way the skin stretches tightly across the cheeks.

The rusting iron stand and the glow of the chestnut-seller's coals cried out for warm hues, but the cold colours overwhelmed the sketch, making even the siennas look chilly.

Snow can bring out the child in us all. Even if we do not join in the games ourselves, there are few greater pleasures than sketching children at play. The bright clothes that young children wear, and the unselfconscious movements and poses that they adopt, make them valuable subjects to the artist. The studies on this page were not all the result of direct observation. A few quick notes to consider the position of a figure moving on a sledge, or the delighted pose in front of a snowman, were combined with much 'visual memory' that comes with experience and practice. These impressions produced some ideas that may, one day, form the basis for a composition.

Here the snow effect was created by lots of tiny, broken brush strokes – almost stippling – on the coat, leaving white paper to show through.

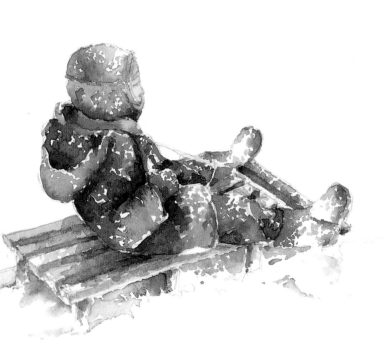

The sense of movement in this study relied heavily on the visual tension created by the straight legs and slightly angled shoulders of the child.

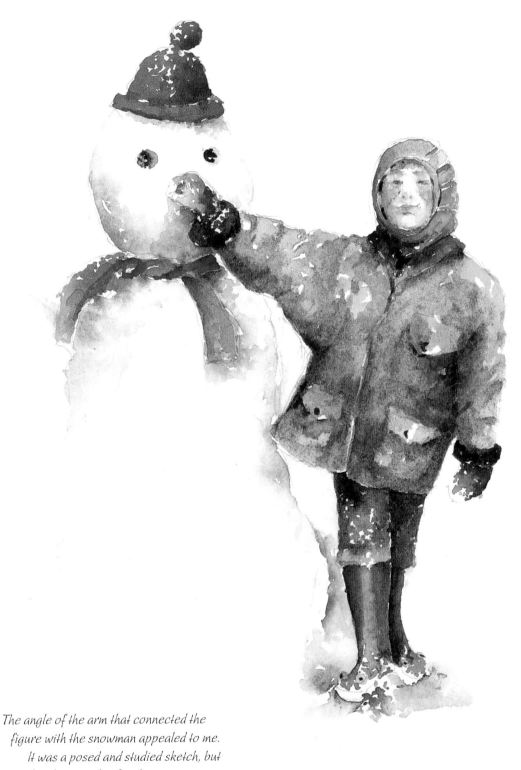

The angle of the arm that connected the figure with the snowman appealed to me. It was a posed and studied sketch, but of no lesser value for that.

Blotting watercolour paintings can serve to force paint into the fibres of the paper to create texture, or to remove wet paint from the paper surface. Depending on the result you wish to achieve, the only difference between the two methods is the amount of pressure applied. When the cold chill of winter sets in and people start to light fires in their homes, smoke can often be seen breaking the lines of the landscape. This is best achieved by removing the paint from the sky and rooftops in the painting while it is still wet by blotting it with a thin piece of kitchen roll. This has the effect of suggesting smoke.

Smoke will always diffuse the subject viewed through it – hills, rooftops, etc. – so these are the areas that need to be blotted to give a softer, misty appearance. Rather like water, smoke is one of those subjects that you do not really paint – you simply change the appearance of the subjects seen through it.

1 Having established the underwash, using a lot of water so that the watercolour paper remains damp for a long time, quickly apply some kitchen roll to the paper in a line. The kitchen roll will gently absorb the surface paint that has not yet soaked into the paper, leaving a light, but not noticeably white, patch.

2 The process of applying paint has to be done quickly as the edges of the blotted areas need to stay damp. As watercolour paint will not readily run into dried paper, the next application of paint could be painted quickly right up to the edge of the blotted area. The paint will not dry to a hard line, but gently bleed around the edges.

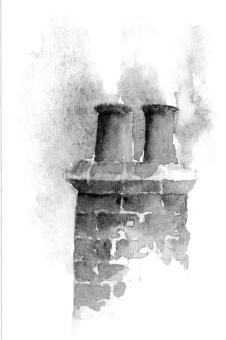

It is worth observing carefully the way in which smoke comes out of chimney pots – it does not always go straight upwards, but is blown by the wind.

3 Once the paint has dried fully, the blotted area can be gently worked over with a putty eraser to lighten selected areas.

SUMMING UP

Blotting needs to done gently. It differs from the texturing technique in that it seeks to lift water and not to force it into the fibres of the paper.

When rain, sleet, or the first real snows of winter begin, you may wish to try recording these by spattering either white paint or masking fluid. Both will have a similar effect, although masking fluid may be a little more effective. Use a toothbrush for this technique.

The most important consideration is to have your paint or masking fluid in a bowl or container that is big enough for you to dip a toothbrush head into. Remember, however, that both paint and masking fluid will dry if you leave them out for too long.

1 Creating a structural drawing either for buildings, trees or even rolling background hills, provides a valuable framework to which to apply paint. In this particular case, however, much of the linear structure would be ignored as the random application of masking fluid and the wet, watery washes start to take control of the painting.

2 Dip a toothbrush into the masking fluid so that all of the bristles are wet. An even coating is ideal as you will get blobs and splodges on your painting if you load too much liquid onto the toothbrush. Then, holding the toothbrush upside down approximately 5 cm (2 in) above the surface of the paper, run your thumb swiftly along the line of bristles, flicking the liquid rapidly across your picture.

3 You might like to experiment with this technique on scrap paper if you are using paint as you will have only one chance when you spatter your picture. If it goes wrong you will not be able to remove the paint. Flick the paint in a diagonal line downwards across the paper as this will give a more natural look to the rain, sleet or snow.

A small section of a fence with accumulated snow makes a suitable subject for trying out masking techniques.

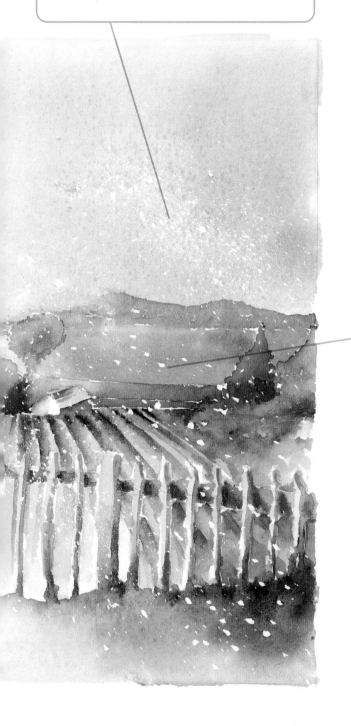

4 Once the masking fluid has dried you can begin to wash colour across the paper. Owing to its 'rubbery' nature water will not permeate or penetrate the flecks of masking fluid, leaving the underneath pure white. It is best to keep your brush strokes even and flat so that there is no risk of removing the flecks of masking fluid with your brush before you are ready.

SUMMING UP

Spattering is a technique best practised a few times on a small scale before committing yourself to a more substantial piece.

On wet, stormy days in winter figures can often be found grouped together under shelters or in shopping malls, waiting for the rain to pass before they carry on with their shopping. Trying to record a lot of detail in such situations is unrealistic, so forget about attempting to depict any personal characteristics of the people. Simplify the scene by viewing the figures as dabs of colour, taking your references from their clothing.

These two figures required little colour, just a variety of tones with Payne's Grey used for darkening folds and creases.

1 It is quite important to establish some of the key figures in a crowd by sketching the head and shoulder outlines of those in the foreground, and the whole bodies of those in the background.

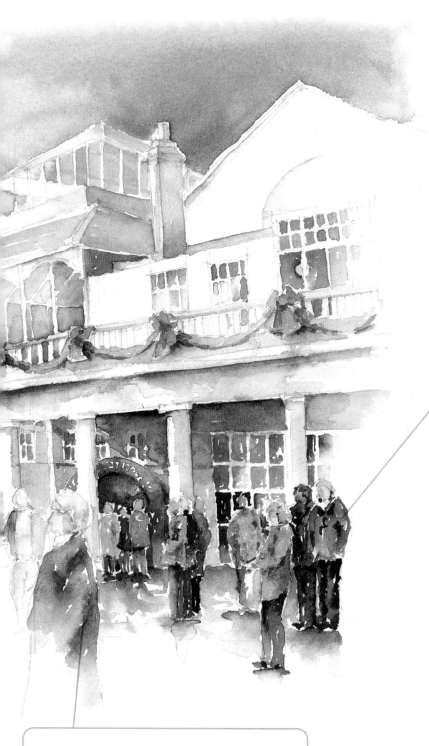

3 When the underwash is fully dry, use a small brush to quickly add a few clothing lines around the arms and under the coats or jackets using a darker mixture of the underwash. Any more than a few marks will add more detail than is required and defeat your attempt at capturing the essence of the scene.

SUMMING UP

Do not be intimidated by crowds. Just focus on a few foreground heads and shoulders. Remember that you will usually be able to use dark, non-descript colours for most people in a crowd scene.

2 Apply an underwash mixture of Payne's Grey, Cobalt Blue and a touch of Burnt Umber to the bulk of the figures – most people will be wearing dark coats at this time of year. Paint the faces and heads with a watery mixture of Raw Sienna and Rose Madder.

When starting to set up or compose a group of objects it is important to consider the shapes created by the visual lines of the group. These can divide the picture frame in half, creating two distinct sets of shapes – the bottom half of the composition and the top half. The bottom half will usually contain foreground information for the viewer to focus on, but the top half will probably have little detail to look at. Thus the top half of the picture frame needs to be particularly well composed with a balanced shape.

The viewer's eye is instantly drawn to the tall bottle on the far right of the composition, creating an area of focus that is balanced by the spaces on the far left.

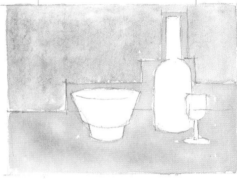

Placing the bottle in the centre of the picture frame produces a passive and rather uninteresting composition.

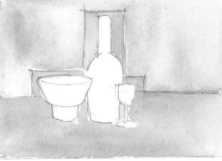

The amount of space in the top half of the picture frame is a little too much to hold the viewer's interest and does not succeed in creating any visual tension.

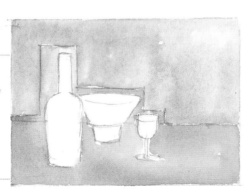

A simple bottle and glass prove to be good subjects to practise organizing a composition. The exact position of the glass in front of the bottle and the placing of the bottle cap are critical. Special attention is given to the spaces in between these three objects and the outline created by their shapes.

This group of ingredients for a festive punch did not automatically work as a table-top study and needed to be arranged well in order to make a successful composition. The small fruit sections needed careful consideration to create an even and equal visual balance. You will find that it is usually harder to arrange several small objects into a pleasing composition than it is to position one or two larger objects.

An old wooden chopping board seemed a suitable base for this 'busy' group as it held some colour but no detail other than the natural grain to detract from the complexity of the forms positioned on top of it.

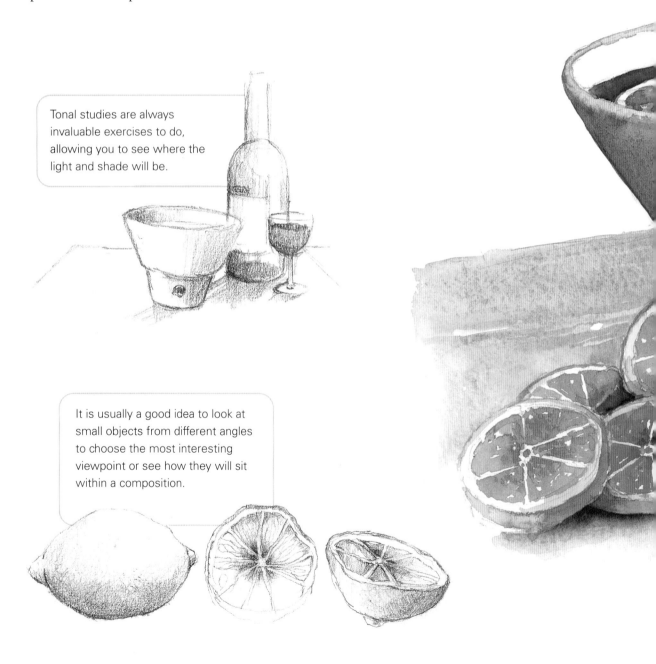

Tonal studies are always invaluable exercises to do, allowing you to see where the light and shade will be.

It is usually a good idea to look at small objects from different angles to choose the most interesting viewpoint or see how they will sit within a composition.

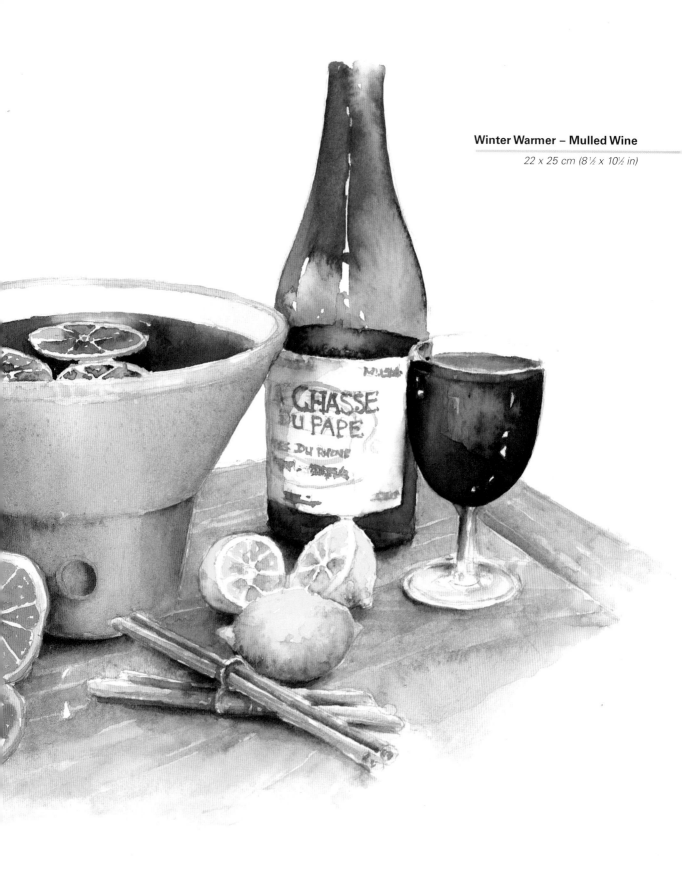

CHASSE
DU PAPE

When snow falls and lays it gently accumulates and gains in height until it is blown by the winds, drifting across the landscape or woodland. Settled on trees, it clings and hangs from the branches and boughs, sometimes in its powdered form, or sometimes frozen on in lumps. It rarely sits regularly, however, as it is fragile and falls and shifts with the movement of the tree.

This particular study is concerned with one particular tree, observing the way in which the snow sits, or almost hangs, on the branches and pine needles.

In order to push the snow forward visually the areas underneath the snow on the trees were painted with a much darker tone of green. The shaded areas underneath the accumulations of snow were painted with a cool violet mixture made from Cobalt Blue and a touch of Alizarin Crimson. This was applied to dry paper using a small paintbrush. Then, before it dried, the edge was washed upwards into the snow with clear water to prevent a hard line occurring around the shadow.

The First Snows of Winter
23 x 24 cm (9 x 9½ in)

The lines and shapes of the clumps of snow were carefully observed and recorded by leaving the areas as pure white paper.

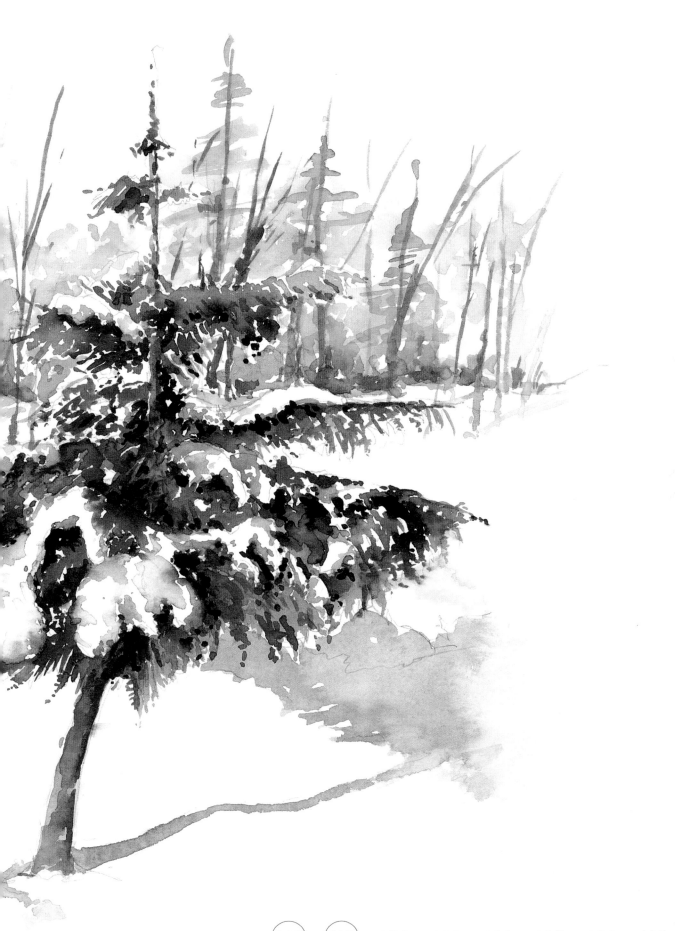

1

The preparatory work for this composition involved producing a strong pencil drawing to provide a visual framework. Masking fluid was then flicked onto this to preserve the impression of snow falling (see Spattering, pages 110–111).Once the masking fluid was dry, the background sky and mountain were painted. The sky required a mixture of mostly Cobalt Blue with a touch of Payne's Grey painted onto damp paper. For the mountain this mixture was reversed, with mostly Payne's Grey and a little Cobalt Blue, but also painted onto damp paper.

2

The cold bluish tones of the middle ground were painted by mixing a little of the sky colour with Terre Verte, a grey-green paint. This colour was blocked in between the trees, leaving them standing as negative shapes. The paint would soon dry to form the undercoat for the middle-distance trees.

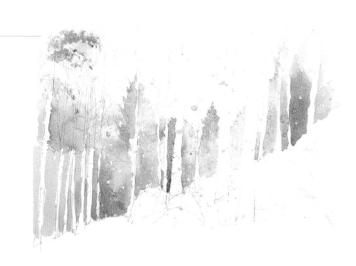

3

A much stronger mixture of Terre Verte and the sky colour (with a little more blue added) was then used to paint behind the shapes of the trees to create highlights. The darkest areas were created at the base of the trees where little light would penetrate.

4

As the middle-ground trees began to take shape, I added a touch of Raw Sienna to the tree mixture and dropped this onto the wet paint. The colour bled and spread, accordingly softening its colour and creating a little more visual interest to the line of trees.

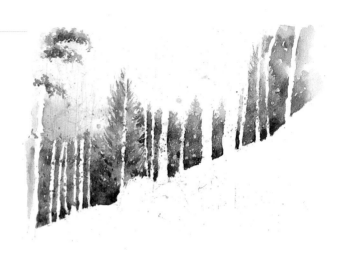

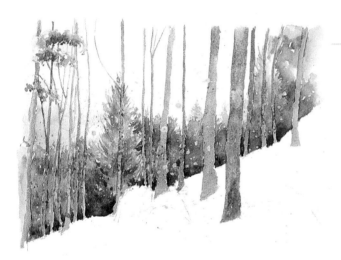

5

Once the foliage had dried the underwash was applied to the trunks of the trees. This was created by mixing Raw Sienna, Burnt Umber and a little of the sky mixture, and was 'pulled' down along the length of the trees using a small brush.

6

The form of the trees was created by increasing the amount of Burnt Umber in the mixture and running a line of paint along the right-hand side of the trees while the underwash was still damp. This allowed the paint to bleed a little, preventing hard edges occurring.

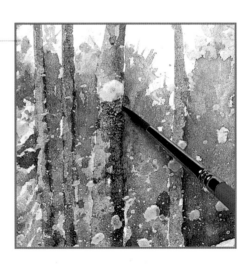

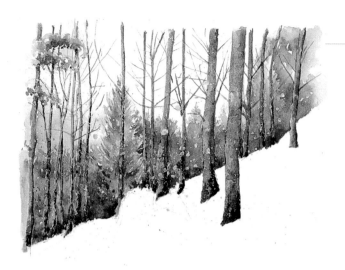

7

The middle and foreground trees were all treated in exactly the same way, ensuring that the base of the trees were also darkened. The branches and twigs were painted using the tip of a small brush to draw in paint.

8

As soon as the paint had fully dried the masking fluid was removed from the upper section of the composition to see exactly how the snow effect had worked. This was done by gently using a putty eraser to remove the dried masking fluid.

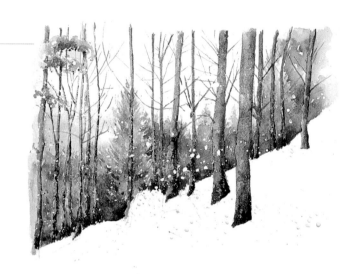

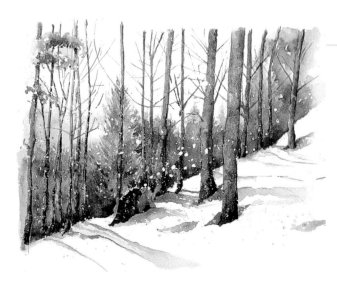

9

The shadows were painted onto dry paper using confident, one-stroke applications, pulling the paint from the point of contact with the subject out across the paper. The colour was a mixture of Alizarin Crimson and Cobalt Blue.

10

The 'holes' in the snow around the bases of trees and trunks were painted, again onto dry paper, using a mixture of both the shadow and the tree colours. This produced a very dark colour, which was applied with a small brush.

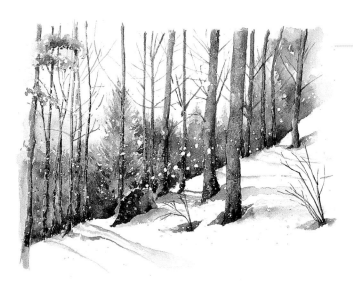

11

The bare, skeletal branches of the shrubs that occupied the foreground were 'sketched' in paint. As soon as this paint had dried, the masking fluid from the lower section could be rubbed off, again gently using a putty eraser.

12

Final touches were made to the painting – sharpening lines and edges and adding a few twigs here and there just to complete the contrast.

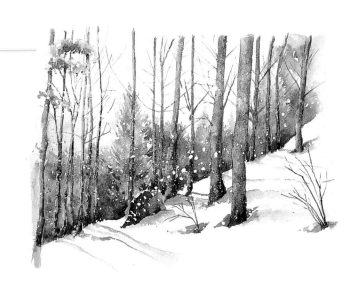

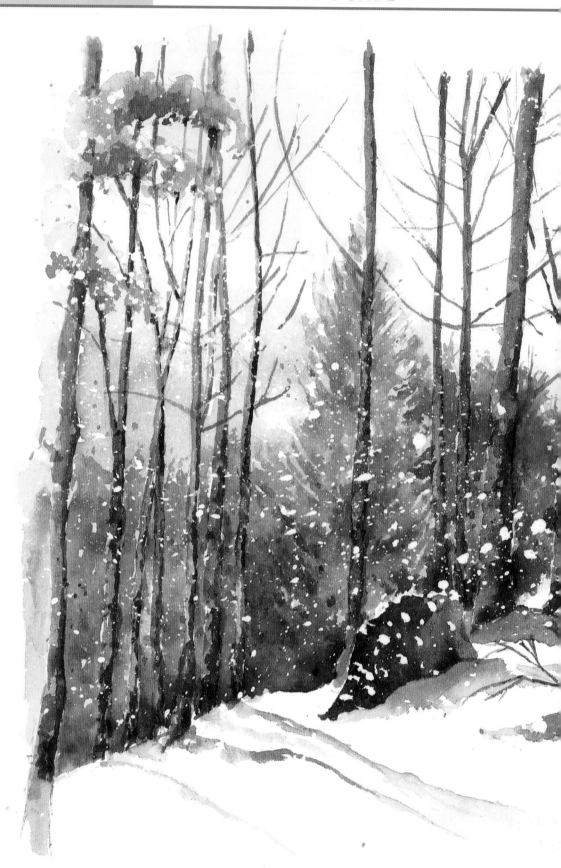

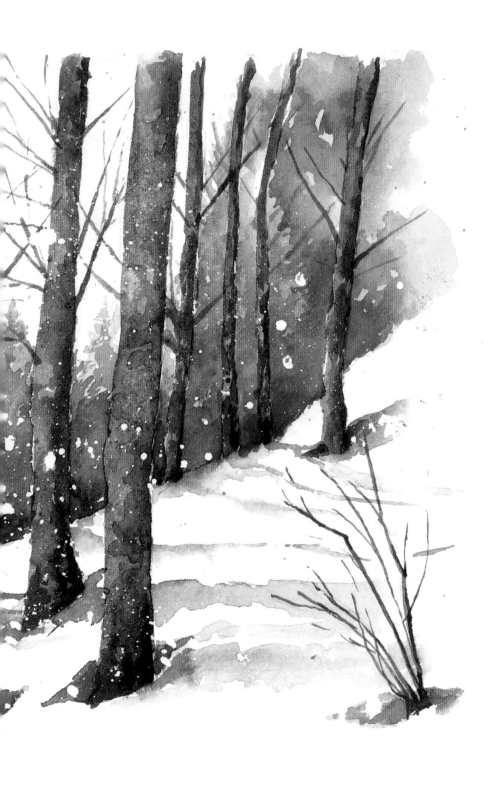

CONCLUDING THOUGHTS

Summary Day in the Woods

14 x 16 cm (5½ x 6 in)

Much of the colour in this painting is enhanced by the 'sandwiching' effect. The colours of the trees are reflected in the water below, leaving only a flash of white water in the centre of the composition.

Every season of the year is both challenging and inspiring for the artist and, equally, every season has its disadvantages and benefits. The warm, balmy days of summer are usually much more appealing to the outdoor painter than the short, windswept winter days with temperatures that are noticeably different. But do not be too discouraged by inclement weather – an outdoor painting does not necessarily mean a major expedition. A small pocket-size sketchpad can be very valuable for making quick, spontaneous sketches that take only a minute or two to do. Aim for just a few 'visual notes' to act as reminders to take home. These and your own personal visual memory are all you need to develop a more substantial piece of painting.

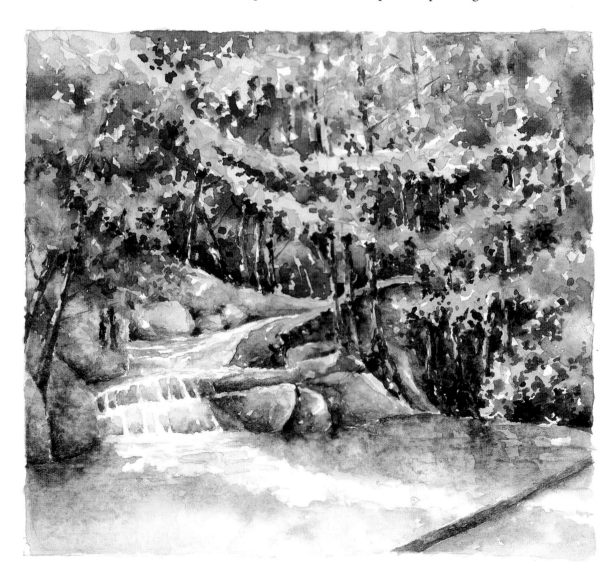

where to paint

This brings me on to another point – where you actually paint. You do not need a purpose-built 'studio' or even a separate room of your own to paint in, however desirable these may be. You can actually paint anywhere. A painting completed in your kitchen amidst the smells and aromas of spices and herbs can often look much more inspired than a painting created away from its natural environment. Equally, the cracked terracotta pot by your back doorstep will probably mean more to you if it is painted just where it is, with the warm summer sun sitting gently on your watercolour pad. The experience of creating a painting can be worth much more than the end result.

Personally, I paint and sketch wherever and whenever I can, and I strongly recommend that you develop a similar practice. Whether your home is large or small or you live in quiet privacy or surrounded by happily rampaging children there is always a subject to be found. Practice will serve to increase your artistic flexibility.

Finally, enjoy the seasons, their vagaries, their subtleties, their eccentricities and the excitement that each can bring – and especially the products that are unique to each one. I certainly do.

Acorn Study
11 x 12 cm (4 x 5 in)

Sometimes it is a good idea to look downwards at your feet for an inspired choice of sketchbook subjects.

INDEX